BEAUTY AND ISLAM

Beauty and Islam

Aesthetics in Islamic Art and Architecture

VALÉRIE GONZALEZ

I.B.Tauris *Publishers*
LONDON • NEW YORK
in association with
The Institute of Ismaili Studies
LONDON

Published in 2001 by I.B.Tauris & Co Ltd
6 Salem Rd, London W2 4BU
175 Fifth Avenue, New York NY 10010
www.ibtauris.com

in association with
The Institute of Ismaili Studies
42–44 Grosvenor Gardens, London SW1W OEB
www.iis.ac.uk

In the United States of America and in Canada distributed by
St Martins Press, 175 Fifth Avenue, New York NY 10010

ISBN 1 86064 691 3

A full CIP record for this book is available from the British Library
A full CIP record for this book is available from the Library of Congress

Library of Congress catalog card: available

Typeset in ITC New Baskerville by Hepton Books, Oxford
Printed and bound in Great Britain by MPG Books Ltd, Bodmin

The Institute of Ismaili Studies

The Institute of Ismaili Studies was established in 1977 with the object of promoting scholarship and learning on Islam, in the historical as well as contemporary contexts, and a better understanding of its relationship with other societies and faiths.

The Institute's programmes encourage a perspective which is not confined to the theological and religious heritage of Islam, but seeks to explore the relationship of religious ideas to broader dimensions of society and culture. The programmes thus encourage an interdisciplinary approach to the materials of Islamic history and thought. Particular attention is also given to issues of modernity that arise as Muslims seek to relate their heritage to the contemporary situation.

Within the Islamic tradition, the Institute's programmes seek to promote research on those areas which have, to date, received relatively little attention from scholars. These include the intellectual and literary expressions of Shi'ism in general, and Ismailism in particular.

In the context of Islamic societies, the Institute's programmes are informed by the full range and diversity of cultures in which Islam is practised today, from the Middle East, South and Central Asia and Africa to the industrialised societies of the West, thus taking into

consideration the variety of contexts which shape the ideals, beliefs and practices of the faith.

These objectives are realised through concrete programmes and activities organised and implemented by various departments of the Institute. The Institute also collaborates periodically, on a programme-specific basis, with other institutions of learning in the United Kingdom and abroad.

The Institute's academic publications fall into several distinct and interrelated categories:

1. Occasional papers or essays addressing broad themes of the relationship between religion and society in the historical as well as modern contexts, with special reference to Islam.
2. Monographs exploring specific aspects of Islamic faith and culture, or the contributions of individual Muslim figures or writers.
3. Editions or translations of significant primary or secondary texts.
4. Translations of poetic or literary texts which illustrate the rich heritage of spiritual, devotional and symbolic expressions in Muslim history.
5. Works on Ismaili history and thought, and the relationship of the Ismailis to other traditions, communities and schools of thought in Islam.
6. Proceedings of conferences and seminars sponsored by the Institute.
7. Bibliographical works and catalogues which document manuscripts, printed texts and other source materials.

This book falls into category six listed above.

In facilitating these and other publications, the Institute's sole aim is to encourage original research and analysis of relevant issues. While every effort is made to ensure that the publications are of a high academic standard, there is naturally bound to be a diversity of views, ideas and interpretations. As such, the opinions expressed in these publications must be understood as belonging to their authors alone.

Contents

List of Illustrations

Foreword

Following the seminal works of great scholars of Islamic art such as Oleg Grabar and Richard Ettinghausen, and the fateful textual studies of senior historians such as A.I. Sabra, a new era in the wider field of Islamic studies seems to have begun – an era these very scholars helped usher in. From Gülru Necipoğlu's rigorous studies of geometry and ornament in Islamic architecture, for example, a work that opened many new vistas, through Antonio Fernandez Puertas' significantly fresh examination of the Alhambra, we have seen the publication of a major work by José Miguel Puerta Vílchez which throws into sharp relief several fundamental questions of a cultural, philosophical and methodological kind, effectively calling into question what had hardened as a scholarly orthodoxy among many art historians in the general field of Islamic intellectual history.

Valérie Gonzalez refers in her work to the writings of all these scholars, and draws heavily upon Puerta Vílchez. But this book, based largely on a series of lectures delivered at The Institute of Ismaili Studies in London, stands not only as an emblem of a new era in the field of Islamic art, but also breaks much new ground, mapping out yet another direction in a new and robust scholarly milieu. Breaking the older mould of studying Islamic art exclusively in historical, sociological and enumerative perspectives, Gonzalez takes a substantive and daring

methodological leap. She uses *aesthetics* both at the meta- and the object-level, and both as theory and method, to explicate not only Islamic texts containing conceptual discourses on beauty, as Puerta Vílchez has so ably done, but also to analyse in the framework of aesthetic phenomenology the actual embodiment of the works of art themselves. It is here that she adds her own new dimension to the study of Islam's artistic production.

But more than this, in her aesthetic analysis, Gonzalez uses modern Western tools and applies them to Islamic data, thus pulling down the dilapidated wall of methodological and cultural separation. The reader is likely to agree with me that she has in this way brought in a breath of fresh air and a good deal of illumination. One of the most significant consequences of bringing together what have typically been considered two disparate realms—namely, Islamic data and modern Western methodology—is that it re-positions the study of Islamic art in the mainstream of contemporary intellectual and cultural discourse, rather than relegating it to 'area studies', 'minority studies', or studies of 'foreign cultures'. This is precisely what Oleg Grabar had pioneered, but in the other direction.

The range of synthesis in this book is impressively, and unusually, wide. We meet in its pages not only Ibn Sīnā, Ibn Rushd, Ibn al-Haytham and many other medieval Muslim sages, but also modern Western philosophers such as Wittgenstein and Nelson Goodman, phenomenologists such as Bachelard and Husserl, artists such as Yves Klein and Mark Rothko, and even contemporary thinkers such as Jacques Derrida—all fully integrated into the book's narrative. It is a wonderful and meaningful experience to see a Derrida or a Wittgenstein being called upon in the course of an explication of a Qur'anic verse; or to witness a Husserl being approached in an aesthetic analysis of the Islamic marvel called the Alhambra. This is nothing less than a rehabilitation of Islamic studies into the scholarly mainstream of our contemporary concerns.

Gonzalez deals with several fundamental aesthetic issues in the course of her analysis—both of texts and of concrete artistic forms. There is a fascinating discussion in the book of a Qur'anic verse which relates the story of the Queen of Sheba's visit to the palace of the Prophet-King

Solomon, a visit in which the Queen mistakes the crystal-clear glass floor of the palace for real water. Here textual analysis goes hand in hand with an aesthetic analysis, considering optical questions, such as that of isotropy, along with semantic and semiotic questions. In her narrative, Gonzalez articulates the important distinction between the aesthetic concepts of resemblance and of representation, speaking of the 'dialectical tension' generated by the formal process of resemblance between artefacts (Solomonic device) and their models in nature (water). From all this emerges a very significant aesthetic and metaphysical conclusion— the artefact and its model are not to be confused; nature and art do not admit of permutation, nor of the substitution of one for the other. This, of course, contravenes the Aristotelian view of art as essentially mimetic: we learn from Gonzalez that the Qur'an, at least in the verse under examination, manifests an absolute 'non-recognition' of imitative or mimetic artistic creation. The author has in this way been able to provide us with a powerful characterisation of the Qur'an's aesthetic ethos.

This whole, and very fruitful, question of representation is raised again when Gonzalez turns to the analysis of an artistic creation, the Comares Hall of the Alhambra. She challenges the standard view that the visual forms here formulate in the physical substance what the parietal inscriptions say in words, and that the Comares dome is a representational embodiment of the seven Islamic heavens. Dismissing this view on fairly rigorous phenomenological grounds, she demonstrates that in the *formal territory* of the Alhambra there is no concrete localisation of *textual iconology*; they constitute two *autonomous* aesthetic fields. The Alhambra, Gonzalez concludes, embodies a dynamic system of visual and textual metaphors. All this amounts to a welcome freshness of analysis and the opening up of many new and illuminating issues.

Gonzalez also takes the question of geometric ornament, tackled in a masterly fashion by Necipoğlu, into new and uncharted territory. She constructs an aesthetic phenomenology of geometric ornament in the Alhambra, and discusses its purpose as well as its logic in the 'language of material expression'. Here again, the harvest is plentiful. And in the same vein—that is, in the spirit of a discoverer than of an expounder— Gonzalez concludes the book with a chapter on the aesthetic system of

inscriptions. For this final discourse, she builds upon the methodological ground that she has prepared in the preceding chapters. Having cogently argued that inscriptions constitute an autonomous artistic sphere in Islam, she now has the justification and the prospects for studying inscriptions in their own aesthetic right. The book in this way reaps its own fruit, becoming its own proof.

I am sure that this work will delight not only scholars of Islamic art and those interested in the wider area of Islamic studies, but also historians and practitioners of art in general, as well as contemporary philosophers.

S. Nomanul Haq
Rutgers University and University of Pennsylvania

Preface

Four of the chapters in this book (the exception being Chapter 4 on geometry in the Alhambra) are based on a seminar series held at The Institute of Ismaili Studies, which now does me the honour of publishing them. For this I would like to thank all those who have shown interest in my work, and made this book possible: Miriam Ali de Unzaga who initiated my visit to the Institute and organised the seminar; Professor Azim Nanji, the Director, who invited me and showed much kindness; Dr Farhad Daftary, Head of the Department of Academic Research and Publications who supported the project; Kutub Kassam who provided assistance in preparing it for publication, and Patricia Salazar who edited the text and found the pictures. I would like also to thank Professor Oleg Grabar of the Institute for Advanced Study in Princeton and Professor Jean-Claude Garcin of the University of Aix-en-Provence, who gave me continual advice and scholarly as well as friendly encouragement in my research on Islamic art and aesthetics, and Professor Robert Ilbert, Director of the Maison Méditerranéenne des Sciences de l'Homme, who extended both intellectual and cordial help, as well as practical support for my research.

All translations into English in the book are my own.

Valérie Gonzalez
Ecole d'Architecture de Marseille-Luminy

The sap of trees runs within his eyes, limpid, live, green
— a wellspring of splendour and dreams.

Introduction

This work deals with what is usually called 'aesthetics' in the framework of Islamic civilisation. Aesthetics is 'the branch of philosophy that examines the nature of art and the character of our experience of art and of the natural environment...'[1] Aesthetics can also be 'applied' in the sense that its object of examination can be a specific and concrete work of art, not only an artistic concept or question. More accurately, the book concerns the particular discipline known as 'aesthetic phenomenology', insofar as it means—to borrow a clear statement by Eliane Escoubias— 'to understand how the mode of access to art, the mode of access to what the work of art contains in terms of art, is a phenomenological mode, is first of all to understand that art has always been and will always be phenomenological'.[2] Aesthetics, and particularly aesthetic phenomenology, forms a specific and new field, which is still not taken into account in the realm of Islamic studies, although it is fully integrated into contemporary analytical works on art and art theory.

Two things are at the root of this situation. The first, of an epistemological order, concerns aesthetics itself as a science and mode of thought which seems to emanate from the philosophical tradition of the modern Western world. Thus it is considered as more or less intrinsically linked to the rules, principles and logic of this tradition and, consequently, not truly adaptable to the thinking and the arts of other

1

civilisations. The second, of a cultural order, deals with the Islamic concept of the practice of the arts, or more accurately, what this is commonly considered to be. On the one hand, this concept carries—as everyone knows—some normative constraints (against the representation of living things in visual forms) and, on the other hand, it has no clearly defined rules or doctrine outlined in texts and treatises, as in the Western world.

One might quickly deduce from such evidence that, as a specialised branch of thought, aesthetics did not properly exist in Islam. Except for a few rare attempts indicating a desire to find aesthetic elements in Islamic written sources, this idea was commonly held until the recent publication of a major book by the Spanish scholar José Miguel Puerta Vílchez.[3] In his book Vílchez outlines a history of aesthetics in classical Arabic thought that clearly demonstrates the existence of this branch of philosophy in the Islamic, as well as in the Latin Middle Ages. From this point of view, Puerta Vílchez's work joins the renowned anthology on Christian aesthetics written by Edgar de Bruyne.[4] But beyond this field of philology and textual analysis, it is still generally thought that the Islamic arts themselves can only really be considered from the historical, sociological and descriptive points of view. Very few scholars take the initiative to use aesthetics as theory and method in order to understand the conceptualisation and the forms of works of art. Nevertheless, as in the abstract sphere of pure thought, there is much to learn about Islamic artistic creation through the aesthetic approach. My aim in this book is to demonstrate this and to thus encourage works of the same kind in the future. What then, does this approach consist of?

The field of aesthetics falls into two interconnected but distinct spheres: primary aesthetics, or 'meta-aesthetics' we should say, which consists of philosophical activity whose object is the beautiful and the experience of beauty; and aesthetics in the modern and specialised sense which is both a practical and a theoretical knowledge of artistic creation. Naturally, by virtue of its purpose and/or its ability to produce beauty, art involves both kinds of cognitive practice since it is basically the tangible result and the expression of a certain concept of the beautiful. Therefore, there are two paths towards an understanding of

aesthetics: the study of texts through which one defines the concept of beauty and the doctrine of the creation of art; and the direct observation of artistic forms as meaningful things and the experience they induce. These paths clearly constitute separate subjects for reflection. However, though it is far from easy to relate texts and arts in the framework of Islam, the former necessarily contain useful material for the grasp of the latter. The next chapter, dealing with sura *al-Naml* (Qur'an 27:44) in the light of aesthetic analysis, shows that there remains a substantial number of unexamined Islamic sources conveying elements of art theory, including the founding book itself, the Qur'an.

In other respects, the question is the method itself on which the aesthetic analysis of both textual and visual matters relies. The original Islamic sources, indeed, shed some light on aesthetics as constituting both a philosophical theory and a concept of artistic practice. In particular aesthetics provides the tools for understanding the intellectual context from which they are generated and wherein the works of art are produced. Nevertheless, these sources alone cannot supply the necessary methodology for dealing with complicated aesthetic problems like the specific question of representation, since, as already mentioned, epistemologically these problems proceed from centuries of Western thought and artistic endeavour. It therefore means that one has to use tools which do not belong *a fortiori* to the cultural area under observation. Taking this necessity into account, part of my work has consisted in gathering new methodological and intellectual material that is used in the study of other arts in other cultural contexts; namely the very rich and diversified body of contemporary material. The latter includes works by artists from recent times, such as Yves Klein or Mark Rothko, writings of theoreticians of art like Arthur Danto or Nelson Goodman, and also the works of philosophers of various schools like the logician Wittgenstein, the phenomenologists Gaston Bachelard and Edmund Husserl, and contemporary thinkers such as Jacques Derrida and Michel Serres, among others. Phenomenological works, in particular, allow a deeper grasp of the primordial meanings of forms and intelligibles that, in the framework of the visual arts, help to reveal the essence of being of an object as it *appears* to the sight, providing an invaluable source of knowledge. All

3

of these authors have dealt with aesthetics and art and, finding their words illuminating, I have not hesitated to quote them, to rely on them and to incorporate them in my own argument. Similarly it has seemed to me relevant to mention, for the sake of comparison, some contemporary artistic works.

Thus, from the perspective of aesthetic enquiry from both these perspectives, of the five chapters in this book the first two are dedicated to textual studies, forming the purely theoretical part. Preceding the Qur'anic exploration, the text begins with an analysis of four famous philosophers that aims to supply a kind of model vision of the various ways of approaching beauty and the aesthetic experience in the Islamic Middle Ages. The other three chapters, forming the part we may call 'applied aesthetics', deal with selected aspects of artistic production that imply aesthetic conceptualisation highly indicative of the Islamic approach to visual language. It concerns, on the one hand, the geometrical design that, as the two texts on the Alhambra show, raises complex questions related to the aesthetic dialectic between abstraction and representation, and on the other hand, the signifying system of inscriptions, examined in the final chapter. Hopefully these chapters will open new possibilities for the understanding of Islamic artistic creation.

1

Beauty and the Aesthetic Experience in Classical Arabic Thought

For all beauty which is suitable and goodness which one perceives (*kull jamāl mulā'im wa-khayr mudrak*), that one loves and desires (*maḥbūb wa ma'shūq*), the principle of perceiving them (*mabda' idrākihi*) relies on the senses (*ḥiss*), imagination (*khayāl*), the estimative faculty (*wahm*), conjecture (*ẓann*) and the intellect (*'aql*).

Ibn Sīnā[1]

This first chapter deals with several aspects of the concept of beauty and ugliness in classical Arabic thought, *falsafa*. Beauty and ugliness are primary and elementary universal notions within the field of aesthetics which, we must remember, began in Greek philosophy with Plato and Aristotle. Within any cultural context, a discussion of aesthetics will involve these notions, whether concerning the Great Creation, nature, or art which belongs to human creation. Since the Middle Ages, Muslim thinkers have discussed, either directly or indirectly, the binary concept of beauty and its opposite, ugliness. As a result, aesthetics was as much a part of classical Arabic philosophy as it was of the Christian thought of the Middle Ages, which we know from the huge corpus of texts written by the Scholastics.

5

Before beginning our enquiry, let us recall the two principal works dealing with medieval aesthetics which we have used as sources for both original and translated material: *Historia del pensamiento estético árabe, al-Andalus y la estética árabe clásica* (History of Arabic Aesthetic Thought, al-Andalus and the Arabic Classical Aesthetic) by José Miguel Puerta Vílchez and *Études d'esthétique médiévale* (Studies in Medieval Aesthetics) by Edgar de Bruyne.[2] Each of these authors has, within his own cultural and scientific sphere, attempted to provide as broad a spectrum as possible of the various aesthetic discussions developed by philosophers, beginning with the basic dialectic of God's creation and human creation that so challenged all the medieval philosophers, whether Muslims, Christians or Jews. These two authors provided the impetus for new perspectives on this particular kind of thought, namely medieval aesthetics, and drew attention to the fact that, from this point of view, the Muslim and Christian worlds were not exclusive but on the contrary closely interconnected.

In order to illustrate the main tendencies which constituted *falsafa* in the Middle Ages, we have selected four celebrated philosophers according to their particular trend of thought.[3] The first, Abū Muḥammad ʿAlī b. Aḥmad ibn Saʿīd ibn Ḥazm (d.456/1064), thinker, poet, jurist and historian from Cordoba, lived during the last days of the Hispano-Umayyad dynasty and the beginning of the Taifa kingdoms. He represents the philosophical movement called *ẓāhirī* in Arabic, which approaches sacred texts in their strictly literal sense, that is to say according to their manifest or exoteric, *ẓāhir*, meaning, as opposed to the hidden or esoteric, *bāṭin*, meaning. All of Ibn Ḥazm's thought depends on this literalness which permeates his aesthetics with the moral and religious ethics which derive from it, that is to say, from the 'letter' of the text.

Abū ʿAlī al-Ḥusayn b. ʿAbd Allāh ibn Sīnā, also known in the West by his Latin name Avicenna, is the next philosopher on our list. Born in Afshāna, near Bukhara, in 370/980, he is one of the most important exponents of Neoplatonic metaphysics in the Muslim world. Like Ibn Ḥazm, he was a politician at various royal courts of Central Asia and Iran, in addition to being both a leading theoretician and practitioner of medicine.

6

The two remaining scholars belong to the so-called 'rationalist' school of philosophers. The first of these is the 'commentator of Aristotle', Abū'l-Walīd Muḥammad b. Aḥmad al-Ḥāfiẓ ibn Rushd, known in Latin sources as Averroës (d.595/1198). Like Ibn Ḥazm, he was born in Cordoba and died in Marrakesh after having worked as a judge (qāḍī) and physician in Seville and at the Almohad court. Like the other philosophers mentioned here, he was a polymath, not only a physician but a jurist and an astronomer too.

Finally we turn to Abū'l-Ḥasan b. al-Ḥasan ibn al-Haytham al-Baṣrī al-Miṣrī, the great physicist, mathematician and astronomer who was born around 354/965 and died in 430/1039. As a thinker, we can consider him a true phenomenologist, long before this term came into use. He spent much of his life in Cairo while it was under Fatimid rule and served under the sixth Fatimid Ismaili Caliph-imam, al-Ḥākim (r.386–411/996–1021). The Scholastics who translated his major treatise on optics, Kitāb al-Manāẓir,[4] under the title Thesaurus Opticus, knew him by various Latin names such as Alhazen, Avenetan or Avennathan.

If these four scholars, along with other Muslim philosophers of the Middle Ages, developed a genuine theory of aesthetics, their ideas nevertheless must be understood according to the medieval conception of the beautiful, that is to say, as a philosophy of sensory experience that does not systematically treat its subject separately as an object of knowledge, or epistemê, but includes it within the wider area of various orders of questions, the ontological, religious and ethical, and their derivatives. We will call this type of thought 'meta-aesthetics'.

This aspect of medieval Arabic aesthetics, characterised by a strong reliance upon other fields of knowledge, manifests itself in particular in the great dual problem of physical beauty and divine beauty, and sensory perception and inner perception. Observable beauty refers to, or is necessarily understood in relation to, the concept of God's beauty. As a result, the visual experience of the beautiful implies, in some way, a spiritual resonance through a noetic perception of a metaphysical nature. As we shall see, Ibn Haytham is the one and only medieval scholar to precede modern thinkers in their attempt to isolate the question of aesthetics from the divine sphere and to consider it in terms of a strictly

human ontology. In other words, he is the first aesthetician if we consider his work from a contemporary perspective formed by centuries of positive thought. In any case, it is precisely these various philosophical colours that make up the richness and originality of medieval aesthetics.

ETHICS, BEAUTY AND UGLINESS IN THE THOUGHT OF IBN ḤAZM

Following the general medieval tendency to integrate the notion of beauty in diverse values, such as the theological value of divine love or the animistic value of yearning after the good (*al-khayr*), the concept of beauty in Ibn Ḥazm's thought possesses several dimensions, material, spiritual and ethical. However, it appears to be mainly developed in relation to his theories of human love on the one hand and moral behaviour, on the other. This Andalusian thinker develops his theories in two famous treatises in particular, the *Risāla fī mudāwāt al-nufūs* (Treatise on Practical Morals) and *Ṭawq al-hamāma* (The Necklace of the Dove).[5] While one clearly concerns ethics, the other provides an ontology of eroticism in literary terms, both works being deeply rooted in the concrete, human realm.

Thus, for the *ẓāhirī* philosopher who conceives the Divine only through a literal interpretation of Qur'anic revelation and who cannot explain it in associative or analogical terms (*tashbīh*) in conjunction with the earthly sphere, God's beauty is a pure abstraction. Consequently, it is strictly within the human domain that beauty can be analysed, considered and objectivised. For example, in chapters five and six of the *Risāla fī mudāwāt al-nufūs*, Ibn Ḥazm attempts to classify and organise the attributes and qualities assigned to perceptible beauty, like sweetness (*ḥalāwa*), gentleness (*diqqa*) or righteousness (*qawām*), into a three-tiered hierarchy. Amongst these, he defines splendour (*raw'a*) and what he considers the sublime physical quality, beauty itself (*al-ḥusn*):

> Splendour is the brightness of the external members (*bahā' al-a'ḍā'l-ẓāhira*); it is also liveliness and nobility (*al-farāha wa'l-'itq*). Beauty is something that has in language no other name (than the one) that designates it, but is unanimously perceived by the souls (*maḥsūs fī'l-nufūs*) when they see it (*fī-ttifāq man ra'ā-hu*). It is like a fine linen covering the face (*burd maksū*

'alā l-wajh), a glance (*ishrāq*) that inclines hearts towards it (*yastamīl al-qulūb naḥwa-hu*), in such a way that opinions (*'arā'*) coincide in judging it beautiful (*istiḥsāni-hi*) and, although it does not possess fine qualities (*ṣifat jamīla*), everyone that sees it, admires it (*rāqa-hu*), considers it beautiful (*istaḥsana-hu*) and accepts it, even though contemplating its separate qualities afterwards, one finds nothing remarkable. It seems like something that lies within the soul of the contemplated object and is found by the soul of whoever contemplates it. This is the highest of the categories of beauty (*ajall marātib al-ṣabāḥa*). Thereafter tastes (*ahwā'*) differ: there is the one who prefers splendour and another who prefers gentleness, but we did not find even one who considers righteousness (*qawām*) as superior in itself.[6]

These attributes and qualities correspond to an objective structure of beauty consciously perceived and, again, situated in real-life experience. In this sense, such an aesthetic conception, related to the notion of desire, follows Aristotle's doctrine, expounded in his *Rhetorics*:

> The beautiful (noble) is what is both desirable for its own sake and also worthy of praise; or that which is both good and also pleasant because good. If this is noble (the beautiful) it follows that excellence must be noble since it is both a good thing and also praiseworthy.[7]

Visually apprehended and submitted to the process of ocular contemplation, the qualities of beauty provoke feelings of empathy and finally love. For Ibn Ḥazm, the human archetype of the beautiful person, endowed with all of the best properties of beauty, is none other than the Prophet Muḥammad himself, the beloved of every believer.

However, beyond these models and theoretical definitions, it is in practice in the love between two lovers, 'a gift of the great divine mercy' (*rahma min Allāh 'azīma*), that beauty finds its fullest completion, its highest manifestation. This idea constitutes the most original aspect of Ibn Ḥazm's conception of the aesthetic. Beauty is especially embodied in the beloved, and refers in general to the phenomenon of love itself: the beauty of lovers and the feelings of love, to which nothing compares, neither the wonders of nature, nor the splendours of art. A highly poetic

and vivid passage in 'The Necklace of the Dove' appears particularly characteristic of Ibn Ḥazm's approach to beauty:

> Neither the leaves and the plants flourishing after the rain, nor the brightness of the flowers after the clouds pass over with the showers of the temperate season, nor the whisper of the spring tides between the branches in bloom, nor the beauty of white palaces (*ta'annuq al-quṣūr al-bīd*) surrounded by green gardens, are better than union with the beloved (*waṣl ḥabīb*), when his characteristics (*akhlāquhu*) satisfy you and you appreciate his innate gifts (*jarā'izu-hu*) and his qualities each correspond in terms of beauty (*taqābalat fi'l-ḥusn*). This is a fact that neither the rhetoricians can express nor the oration of the most eloquent describe.[8]

In this lower world, the ideal of beauty lies, as we can see, in the human realm rather than in the natural. Nevertheless, although the beautiful is embodied in a living body, the ideal body of the Prophet or the beloved's body, it is by no means limited to a range of physical qualities (*al-ḥusn al-khalq*). Despite their undeniable attraction, these qualities possess an ephemeral power and conceal a negative capacity to corrupt reason, whereas true beauty comprises a conjunction of moral, spiritual, intellectual and even physical characteristics that mould themselves into a kind of perfect being or one that tends toward perfection. To love someone endowed with this kind of genuine beauty is absolutely licit and moreover desirable, but only insofar as it implies a passion controlled by reason and by principles of moderation, honesty, balance and other ethical ideals. These aesthetics of love should fulfil the requirement of, in Ibn Ḥazm's own words, 'knowing and perceiving the difference between right and wrong and believing strongly in truth', meaning the truth revealed by God.

In this way, devoting oneself unreservedly to the contemplation of the beloved becomes a delight, that is to say, the contemplation of this beauty insofar as it creates an appreciation in the physical sight in harmony with the soul's perception of what Ibn Ḥazm terms 'his image'. This image is a sort of carnal crystallisation of both visible and invisible qualities, of physical as well as mental properties of attraction. Let us

once again quote the thinker from Cordoba, who as a specialist of *fiqh* or Islamic jurisprudence, has this to say:

> If I love someone it is for myself and for my soul which delights itself with his image (*li-ttidādī-hā bi sūratihi*), and by desiring it (this image) with all my soul, I pursue my logic, I follow my principles and I continue along my way.[9]

According to Ibn Ḥazm's thinking, it follows from these norms and overall conditions of appreciation, that if one is attracted only to well proportioned corporeal forms (*al-ṣuwar al-badī'a al-tarkīb*) and pleasing faces (*al-wujūh al-badī'a*), the beauty one perceives may be associated with corruption, vice and disorder. For moral integrity and cognitive capacities may allow themselves to be dominated by the sensual desires which these splendid forms inevitably stimulate. By induction, from the standpoint of Ibn Ḥazm's logic, ugliness, as opposed to true beauty, corresponds to immorality, uncontrolled instincts and ignorance of religious truth.

We can thus conclude that the Andalusian scholar's aesthetic conception rests upon strict ethics undissociable from the divine revelation, and the primacy of reason over passion and imagination. However, intimately linking the concept of beauty with earthly existence, this conception has a deeply human character, especially as the motivation of the union of love is understood as the ultimate aesthetic goal possible through God's grace. Obviously, the licit enjoyment of the beautiful which occurs in these well defined conditions and through the perception of the senses, can afterwards yield, for those most intellectually and spiritually inclined, to the inner perception of the ultimate beauty, namely, divine beauty. But this can happen only in absolute abstract terms, neither easily assimilated nor even comparable to aesthetic concepts related to human existence. These ideas form the main axis upon which the theory of beauty turns within the *ẓāhirī* philosophy of Ibn Ḥazm.

METAPHYSICAL BEAUTY IN IBN SĪNĀ'S NEOPLATONIC THOUGHT

Unlike *ẓāhirī* thought, the metaphysical aesthetics of the Neoplatonists like al-Fārābī and Ibn Sīnā in the eastern Islamic world, or Ibn Ṭufayl

and Ibn Bājja in al-Andalus, considers beauty in a radically different manner. In accordance with Neoplatonic ideas, the value of the beautiful defended by these thinkers can only be conceived in a spiritual light, more precisely in the light of emanationist cosmology inspired by Greek and Graeco-Latin philosophy. Indeed, as is well known, much of the wisdom of Antiquity was collected and transmitted to the Muslim world through a corpus of great Arabic texts entitled incorrectly *Uthūlūjiyā Arisṭāṭālīs* (The Theology of Aristotle) upon which the medieval *falsafa* is largely founded.[10]

So, following the Neoplatonic cosmological schema, instead of separating the lower earthly sphere and the superior divine sphere into two entities, as we find in Ibn Ḥazm's work, the Muslim metaphysicians put both spheres in a reflexive relationship underpinned by the principle of emanation. The universe emanates from the superior divine world and is consequently a reflection of it, graduated in various levels. This reflexive relationship manifests itself in particular through the Divine Attributes from which proceed the qualities of perfection which the diversified beings in creation possess in variable degrees.

In this emanationist system, the concept of beauty partakes of the definition of God and His Attributes, given that He constitutes the original and sublime beauty and that all His Attributes are characterised by their splendour and absolute perfection. But this divine beauty remains ineffable and its metaphysical structure cannot, therefore, define itself through the conditions of matter. More accurately, the concept of beauty is apprehended in ideal and spiritual terms related to light (*nūr*) and brightness as transcendental qualities, God being designated for example by the expression 'the power of light' (*al-quwwa al-nūriyya*). Therefore, logically, beauty thus determined generates an entire aesthetic of light which has in essence very little connection with the existential world owing to its divine source. This aesthetic is mainly conceptual, based on the double notion of light and splendour and may even be defined as a genuine aesthetics of the Divine.

This metaphysical aesthetic of light lends colour to the search for God's perfection which motivates the spiritual activity of the believer; it concerns an elevating and fundamentally cerebral experience in which

sensory perception constitutes only the initial and necessary level of a process of perception graduated in ascending stages, the intellectual perception (*al-idrāk al-ʿaqlī*) residing in the superior degree. The ultimate goal remains the beatific aspiration to the luminous and radiant splendours of the Divine.

At this point in our account of Islamic metaphysics, we must emphasise that the influence it exerted on the medieval European thought developed by the Scholastics was so powerful that it contributed to the formation of a Christian aesthetics of light in the thirteenth century. The Neoplatonism that flourished from the twelfth century in the Western world with Saint Augustine and the Pseudo-Dionysius, found another path of dissemination through Muslim philosophy and sciences, especially the great metaphysicians translated into Latin such as al-Fārābī (d.339/950), Ibn Sīnā (d.428/1037), al-Ghazālī (d.505/1111) and Suhrawardī (d.c.587/1191).[11] This Christian aesthetic of light was penetrated by Greek, Latin and Arabic ideas, and found expression especially in a seminal thirteenth-century work entitled *Liber De Intelligentiis* (Book of the Intelligences), attributed successively to the famous scholastic Witelo and a relatively unknown scholar named Adam de Belladonna. A mixture of Neoplatonism and Aristotelianism, this book contains an entire theology centred upon the conceptualisation of the world of luminous essence and order, born from the divine light and formed by material bodies animated by luminous energy.[12] In this, we find in the Middle Ages, a *koine* of thoughts that join the Muslim and the Christian worlds through a common set of ideas, notably aesthetic ideas conveyed by the dual tendencies of metaphysical and objectivist views of the universe.[13] We will continue to point out this important fact occasionally in our argument, but now let us turn to Ibn Sīnā's thought.

Relative to the metaphysical cosmological vision derived from Neoplatonism, Ibn Sīnā proposes his own theory of beauty, included in the theology that emerges from his encyclopaedic work, *Kitāb al-Shifāʾ* (Book of Healing) and from what forms a kind of summary of it, *Kitāb al-Najā* (Book of Salvation). Thus, for Ibn Sīnā, beauty forms a polyvalent concept which enters the sphere of the intellect, a pure intellectual essence

inhabiting all kinds of objects, things and beings, an essentialist conception that he expresses in this concise and absolute postulate:

> The beauty (*jamāl*) and splendour (*bahā'*) of all things consists in that everything has to be as it has to be.[14]

This idea was assimilated literally by several Scholastics like Thomas of York who repeated in a similar sentence in Latin, *Pulchritudo et decor rei est ut sit quedadmodum convenit ei*, meaning that beauty (*decorum*) constitutes the quality that something possesses when it is as it has to be.[15]

Starting from this generic definition, the Muslim thinker outlines the notion of beauty with specific determinations, among them some which appear clearly Neoplatonic and more precisely Plotinian, like the alliance of the beautiful with the pure good, and others which introduce new principles like desirability, balance and harmony:

> There cannot exist beauty or splendour more elevated than where the essence (*māhiyya*) is exclusively intellectual (*'aqliyya maḥḍa*) and pure good (*khayriyya maḥḍa*), free from any kind of imperfection (*naqṣ*) and unique (*wāḥida*) in all its aspects.[16]

In this way Ibn Sīnā composes a range of sublime qualities which, of course, only God, the Necessary Being, has in absolute. God is the very origin of these qualities and infuses them into the totality of things and beings:

> The Necessary Being possesses beauty and pure splendour (*al-jamāl wa'l-bahā' al-maḥḍ*) and He is the origin of all harmony, given that every harmony occurs within the multiplicity of one composition or mixture and in this way creates unity in multiplicity.[17]

The divine perfection and unity that combine with the idea of the good (*khayr*) and related notions, corresponds in negative to the quality of the Necessary Being of having no defect and being free of all potentiality. The concepts of imperfection and potentiality indeed introduce several negative properties like uncertainty, disorder, imbalance, etc., that are effectively linked—whether or not the author directly expresses it—to ugliness as a major concept opposed to beauty defined by the

Divine Attributes; a scheme of opposing concepts which in the event characterises the ontological duality of earthly existence in beauty and ugliness, good and evil, and so on. Imperfection and evil, says Ibn Sīnā, lie in the existence that occurs within the sub-lunar sphere, in respect of the hierarchic order of different parts that form the cosmos:

> All the causes of evil are to be found in the sub-lunar realm, all that exists beneath the moon is imperfect compared to all other beings.[18]

From such a divine aesthetic conception comes a desire to incline towards the highest beauty of God, to look for or to rediscover the sublimity of His qualities through a metaphysical quest. Such a quest involves the intellectual effort of thought as well as intuition, and obviously the superior intellection of the soul or spirit. Through this path of meditative introspection, the individual abstracts himself from imperfect and limited matter in order to reach the pure essences, or pure splendour, as Ibn Sīnā explains:

> If we isolate ourselves from the body, we will be, with the help of our meditation, our own essence (*dhāta-nā*), and it (our essence) will be able to become an intellectual world in harmony with true beings (*al-mawjūdāt al-ḥaqīqiyya*), true beauties (*al-jamālāt al-ḥaqīqiyya*) and true delights (*al-maladhdhāt al-ḥaqīqiyya*), joining with them as two intelligibles join together. In such a situation, we will enjoy infinite delight (*ladha*) and splendour (*baha'*).[19]

The rational theories of Ibn Rushd and Ibn al-Haytham's positive minds appear to be completely opposed to this vision of abstract metaphysical beauty proceeding from the divine ideal. In other words, from the absolute intellectual realm where Ibn Sīnā locates it, Ibn Rushd and Ibn al-Haytham, each following his own philosophical view, award to beauty its material specificity. In this sense they confirm the Aristotelian postulate: 'The beautiful is what is pleasant to the eye or to the ear.'[20]

THE IDENTIFICATION OF BEAUTY WITH ORDER IN IBN RUSHD'S THOUGHT

Ibn Rushd's entire philosophy relies on a phenomenal exegesis of Aristotle's works,[21] and it is from this that the Latins gave him the

sobriquet 'the commentator'. His philosophy, and, by extension, his conception of the beautiful thus appears impregnated with the principles of logic and physics of the Greek master. The aesthetics subtending the Rushdian analysis of concreteness or, more precisely, what we can interpret as such, are developed as part of the noetic and metaphysical questions contained in his major texts: *Talkhīṣ kitāb al-nafs* (Summary of the Book of the Soul) and the *Tafsīr mā ba'da'l-ṭabī'a* (Commentary on Aristotle's Metaphysics).

In fact, the concept of beauty according to Ibn Rushd does not shape an authentic theory of aesthetics, insofar as the beautiful is not to be understood either as a value or as a quality *per se*, but has to be deduced from a systematic analytical approach of perceptible reality conceived as a coherent and ordered whole, that is nature created by God. Human beings possess a number of perceptual and cognitive faculties that differentiate them from animals and allow them to establish an existential relationship with the given and perfectly organised fact constituted by the created world, the witness of divine wisdom: thus it concerns a relationship built on speculative knowledge and understanding. Without denying the ultimate goal of knowledge, which consists in proving God's existence and the validity of the divine revelation, Ibn Rushd insists on the necessity of practising logic through syllogism and demonstrations in general in order to understand the world. He even goes so far as to underline the great use of the non-Muslim speculations which can be included in reasoning and contribute to knowledge, as we can see in this syllogistic statement typical of Ibn Rushd:

> For the instrument (logic), thanks to which the purification is valid, makes valid the purification for which it is useful, without needing to examine whether this instrument belongs or not to one of our co-religionists: to fulfil the conditions of validity is enough.[22]

In respect of this positive, almost materialistic vision of the universe, the beautiful identifies itself, in Ibn Rushd's argument, not with a transcendental and sacred value of perfection, but with objective and observable notions of order (*tartīb*), structural cohesiveness and physical harmony (*niẓām*). All these concepts structure a mode of thinking

aesthetics sustained by logical principles of the causality and finality of natural laws. Accordingly, things in general are included in a hierarchy in terms of nobility instead of beauty, a principle that evidently implies the notion of order. Thus Ibn Rushd argues that the physical property of colour 'has, in the First Science (i.e. the science of the First Principle) a more noble existence than all the others (existences), and as concerns existence it is impossible to find a more noble one.'[23]

The grasp of beauty—this kind of beauty/nobility/order—takes effect within the cognitive relationship of the individual to the world and operates necessarily through the sensible perception, the primary condition of knowledge. Thus, everything has a specific essence, a range of objective qualities that the senses perceive and recognise as such; however, this holds good in normal circumstances where perception is free from disturbing elements like disease or variation of mood that prevent a correct understanding of these qualities and essences, and the right evaluation of them. Consequently, such a conception of the beautiful, assimilated with the objective order of the universe, appears more like a logical cognitive phenomenon within the complex range of processes of human understanding than a genuine aesthetic experience. To illustrate this aspect of Ibn Rushd's thought, it suffices to quote a passage of his Middle Commentary on Aristotle's *Rhetorics*. This very significant text concerns the visual experience of some artistic forms, like painting and sculpture that, by definition, stimulate the aesthetic experience and cause pleasure:

> … Aristotle said: If teaching is pleasant and likewise the fact, for humankind, of being admirable and admired, then to make someone imagine and to imitate are equally pleasant because of their similarity with teaching; and this as well as imitation by painting, sculpture and all the other acts through which one seeks to imitate the primary models—I mean existing things—not the acts through which one imitates things that do not exist. Indeed, the delight enjoyed during acts through which one imitates existing things does not come from the fact that these resemblances are beautiful or ugly, but from the fact that in these acts there is a kind of syllogistic activity; then, in the activity of making known something hidden, which is the absent compared to the more manifest, which is the

example put instead of it, there is, in a sense, one of the sorts of teaching that occurs through syllogism, for the imagination of the thing takes relative to it (the thing) the rank of the premise, and the thing that one seeks to imagine and understand takes the rank of the conclusion; and because of this similarity that exists between imagining and teaching, to imagine is pleasant.[24]

It is clear that Ibn Rushd (through Aristotle) does not consider beauty as an aesthetic value in the perception process of the artistic and pedagogic works in question. Actually, the commentary expounds the phenomenology and the psychic implications of this process in the light of the Aristotelian concept of *mimesis,* meaning the imitation of Nature that by essence governs creative and pedagogic acts. In the phenomenology of these acts, *mimesis* does not necessarily produce formal beauty, but opens a cognitive path that appeals to the imaginative faculty, which is why the products these acts create provide delight for the user. Being God's creation, nature pre-exists art, but through art as a visual syllogism, one grasps, discovers and understands nature. Thus, the beauty of a material work cannot be estimated, in this case, through the pleasant or well-composed aspect of its formal configuration, but through the excellence of its mimetic system in so far as it aims at reproducing in some way this perfect structure—in terms of logic—of the universe, and thereby makes it known. Let us quote Ibn Rushd again, talking about the arts in general:

> Art (*al-ṣināʻa*) is, in that sense, more limited than nature (*ṭabīʻa*), given that art generates, within the quantities of colours that exist in the internal logos (*al-nuṭq al-bāṭin*), only what the external logos (*al-nuṭq al-khārij*) is capable of producing. Meanwhile, nature produces all that there exists in the immaterial internal logos (*al-nuṭq al-bāṭin al-rūḥānī*), and that is why nature is nobler than art (*ashraf min al-ṣināʻa*), and the nobility (*sharaf*) of the artist will depend on the degree of excellence (*jawda*) with which he imitates nature, and this within the boundaries of the possible.[25]

We will notice again, in this quotation, the absence of the criterion of beauty for qualifying works of art, a criterion which replaces the hierarchic value of nobility, in accordance with the rational vision of things

emanating from the ontological order conceived by Ibn Rushd. From this point of view, it seems relevant to establish once again a link with the medieval Christian perception of art which presents some aspects in common with our Muslim philosopher's thought in its Aristotelian foundation or connection. For example, the modern scholar Edgar de Bruyne speaks about the doctrine of the liberal arts of such great Carolingian theoreticians as Hraban Maur, Scot Erigène and Rémi Auxerre:

> The liberal arts are not a subjective creation of the mind, they are based on the objective and divine structure of the real and, in the last analysis, of the spirit of God. Whether it concerns arithmetic, geometry, music or astronomy, the human being can only discover the laws of harmony, he cannot create them. So a genius like Pythagoras did not invent music, he discovered it.[26]

We are well aware that Ibn Rushd's system had a remarkable echo in the Latin Middle Ages—even if it was criticised in many respects[27]—especially by thirteenth-century Scholastics like Saint Thomas Aquinas and Albert the Great,[28] as well as Jewish philosophy from the fourteenth and fifteenth centuries, with Levi Ben Gerson or Moises from Narbonne for instance.[29] In this respect concerning the impact on Scholasticism, Ibn Rushd joins Ibn al-Haytham, to whom we shall devote the last part of this chapter.

UNIVERSALITY AND MODERNITY IN IBN AL-HAYTHAM'S AESTHETICS

Ibn al-Haytham's work is situated in the same trend of positive thought founded on a deep knowledge of Greek philosophy and science and a rational observation of man's relationship with nature and its physical laws. This Fatimid scholar proposes an approach to beauty which turns out to be closely linked to a complex phenomenon that he studied both as a physicist and thinker, namely visual perception (*idrāk al-mubṣara*):

> The sight (*al-baṣar*) is composed of various layers, coats and bodies, its principle and origin residing in the frontal part of the brain.[30]

In his famous treatise *Kitāb al-manāẓir* (The Book of Optics),[31] Ibn al-Haytham explores vision, in amazingly modern terms of phenomenology

and psychophysics, as a primary cognitive experience in general. From then on he builds a theory of the sensitive appreciation of beautiful things (*idrāk al-ḥusn*) in particular. But first of all, this corpus provides a scientifically important proposition about the physical process of seeing, thanks to the activities of both light[32] and colour:

> The sight perceives (*yuḥiss*) the light and the colour existing in the surface of the contemplated (*mubṣar*) object, thanks to the shape that expands from the light and the colour existing from the surface of this object through an intermediary diaphanous body (*al-jism al-mushiff al-mutawassiṭ*) between the sight and the object. The vision necessarily perceives all objects by means of supposed straight lines that extend themselves between the object and the central point of the sight (*markaz al-baṣar*).[33]

This theory involves significantly, for the first time in the Middle Ages, the two principles of light and perspective. In fact, added to other works on optics by a galaxy of Muslim scholars, especially those after Euclid,[34] Ibn al-Haytham's treatise belongs to a broad scientific trend in Islamic thought which influenced the entire medieval world, that is to say it had an equal impact on the Christian world, as we will emphasise below. However, Ibn al-Haytham's theory of vision does not limit itself to the strictly scientific realm but deals with deeply aesthetic questions and considerations, taking into account as major objects of analysis the double concept of beauty and ugliness and the observer's experience of it.

Immediately, Ibn al-Haytham recognises beauty and ugliness as objective and visible facts which all objects or corporeal beings (*ajsān*) display in varying degrees, among other objective facts that define them generically and that he calls in Arabic '*al-ma'āni al-mubṣara*', 'perceptual meanings'. The word *ma'na*, which in general designates 'meaning', is translated as 'property' in Sabra's translation and as 'concepts' by Puerta Vílchez. These properties or concepts are gathered into a basic list containing exactly twenty-two notions including light, colour, form, volume and so on.[35] Variously combined with this potential of beauty, these notions form the observable constitutive scheme of the body of things and beings. This objective character of beauty and ugliness can be grasped even by a child, in an inner way, at the primary stage of aesthetic

development in the sense that the child already discerns, compares and evaluates things according to the degree of the qualities they convey and display to the sight. A celebrated text from the second volume of *Kitāb al-manāẓir*, describes this experience:

> For example, if a child who is not extremely young, nor of perfectly (developed) judgement, is shown two things of the same kind, say two rare fruits or garments or such things as children like, and is made to choose between them, then, assuming that one of them is beautiful in appearance (*ḥasan al-ṣūra*) and the other ugly (*qabīḥ al-ṣūra*), he will choose the beautiful one and refuse the ugly one, provided that he has (reached) awareness and is not extremely young. Again, if he is made to choose between two things of the same kind which are both beautiful (*ḥasanayn*), but of which one is more beautiful than the other (*aḥsan*), he will often choose the more beautiful object, even though the other is (also) beautiful, provided that he has (reached) awareness. Now the child's preference for the beautiful over the ugly thing can only be made by comparing one with the other. His perception of the beauty of that which is beautiful and the ugliness of the ugly, and his preference for the beautiful over the ugly, and, again, his choice of the more beautiful (*al-zā'id al-ḥusn*) rather than that which is less so (if he makes such a choice) can only take place after he has compared the two with one another and perceived the form of each and the excess in beauty of the more beautiful over the less beautiful. But preferring the more beautiful can only be due to the universal premise 'what is more beautiful is better (*akhyar*), and what is better is more worthy of choice'. He therefore employs this premise without being aware of it. [36]

Things are variously beautiful according to two principles, says Ibn al-Haytham. The first is that the generic visual properties or concepts—those he listed and counted in determining the corporal constitution of things—contain intrinsic beauty *per se*. For example, light (*al-nūr*), the first in the list of the twenty-two generic notions, 'produces beauty (*al-ḍaw' yaf'al al-ḥusn*), and that is why we consider as beautiful the sun, the moon and the stars; but in the sun, the moon and the stars there exists nothing making them beautiful or providing them with a pleasant shape except their lightness and brightness'.[37]

The second principle is the modulator or the shaping principle of this beauty *per se*, conveyed by the generic visual concepts into a particular, single beauty, thus a measurable, quantifiable and therefore classifiable beauty. This modulation process of the beautiful operates through the specific combination of one, some, or all of these generic visual concepts with the particular, proper visual concepts owned by the form of each thing or each type of thing. So that finally, the specified object offers to the sight and perception a particular category and a particular quality of beauty:

> Now for the beauty that is perceptible to the sense of sight: sight perceives it by perceiving each one of the particular properties (*min idrākihi li'l-ma'ānī al-juz'iyya*) of which the manner of perception by sight has been shown. For each of these properties separately produces one of the kinds of beauty, and they produce other kinds of beauty in conjunction with one another. For sight perceives beauty only from the forms of visible objects which are perceptible to it; and these forms are composed of the particular properties that have been shown in detail; and sight perceives the forms from its perception of these properties; and therefore, it perceives beauty from its perception of these properties.[38]

Among the particular visual properties responsible for the high degree of beauty in an object, there appear those of order (*tartīb*) and symmetry from Aristotle and Plato's aesthetics, which Ibn Haytham revived by combining them with related principles like proportional correspondence (*tanāsub*) and harmony (*nizām*). As a matter of fact, these notions commonly subtend aesthetic theories in Islamic philosophy in the Middle Ages. In general:

> Position (*wad'*) produces beauty, and many things that look beautiful (*nuqūs*) do so only because of order and position. Beautiful writing also is regarded as such because of order alone. For the beauty of writing (*husn al-khatt*) is due only to the soundness of the shapes of letters and their composition among themselves, so that when the composition and order of the letters is not regular and proportionate, the writing will not be beautiful, even though the shapes of individual letters may be correct and sound. Indeed, writing is considered beautiful when of regular

composition, even though the letters in it are not quite sound. Similarly, many forms of visible objects are felt to be beautiful and appealing only because of the composition and order of their parts among themselves.[39]

As both a scientific and aesthetic theory of vision and beauty, Ibn Haytham's corpus on optics had a strong impact on European Christian thought and arts, not only in the Middle Ages but also in the post-medieval period, that is, at the beginning of the 'modern period'. Since the end of the twelfth century, through Dominique Gondissalvi's works which took inspiration from the Arabic sciences, and especially the School of Chartres in France, then fully during the thirteenth century when the Latin translation (*Opticae Thesaurus*) was widely read, the Scholastics confirmed the important rank in the structure of the universe of physics and its corollaries, mathematics and geometry. The positivist thinker Robert Grosseteste (d.1253), Abbot of Lincoln, who was particularly aware of Ibn Haytham's work, claimed:

> It is impossible to know nature without geometry: its principles are present in absolute within the whole universe and every part of it; it is through its lines, angles and figures that we have to represent all the causes of natural phenomena; without this means, it is impossible to reach the 'proper quid' in nature.[40]

With this new positivist conception of the world appeared a new aesthetics, the aesthetics of light that was notably developed through the great programme of cathedral-building and the decisive problem of perspective in paintings.[41] This was a phenomenon occurred more exactly under the threefold influence of the Arabic sciences, Saint Augustine and Neoplatonism (the Pseudo-Dionysius, Ptolemy, Plotinus, etc.).[42] Edgar de Bruyne rightly says:

> Around 1200, translations of the *De Perspectiva* or *De Aspectibus* (On Perspectives) by Alhacen (al-Haytham) are copied: he affirms the spherical diffusion of light, as a mathematician he develops the theory of the luminous ray's reflection and refraction, and, as a positivist, the psycho-physiologist doctrine of visual sensation. Alhacen exerts a great influence on Grosseteste and Bacon and the perspectivists like Witelo and Jean Peckham. The *De Perspectiva* treatise of the first (Witelo), dedicated

to Guillaume de Moerbeke (around 1270), will be commented on by Kepler, the second one (Peckham) deeply inspires the *Trattato della pittura* (The Treatise of Painting) by Leonardo da Vinci, whose aesthetic-scientific trends are well known.[43]

In the Renaissance, philosophical theories concerning the aesthetics of the human proportion based on symmetry as a determining concept of perfection were especially applied in the visual arts, for example by the Italian artist Lorenzo Ghiberti (d.1455),[44] who took as one of his sources—if not his main source—Ibn al-Haytham's conception of observable beauty, defined in terms of objective visual qualities. Let us quote another example of this scholar's aesthetics which is particularly eloquent on the question of proportional correspondence. In a text where he expounds the basic conditions required for human beauty, Ibn al-Haytham says:

> Proportionality (*tanāsub*) alone may produce beauty, provided that the organs are not in themselves ugly, though not perfect in their beauty. Thus, when a form combines the beauty of the shapes of all its parts and the beauty of their magnitudes and their composition and the proportionality of parts in regard to shape, size, position and all the other properties required by proportionality, and moreover, when the organs are proportionate to the shape and size of the face as a whole—that is perfect beauty. A form that has some of these properties to the exclusion of others will be considered beautiful in accordance with what it has of the beautiful properties.[45]

According to Ibn al-Haytham's theory, the beauty that clearly exists in all things must be grasped by the individual in its full complexity, variation and subtlety, as and when his perceptive ability matures, improves and sharpens with practice and use, starting from the elementary experience of the child described in the previously mentioned text. Thus it concerns a complex process of visual perception that appeals to the combination of sensory grasp with a form of understanding derived from the imaginative faculties and other modes of intuitive or pre-logical knowledge. Maurice Merleau-Ponty, the French phenomenologist calls this intuitive mode 'the instinctive infrastructure of perception' as opposed

to logical modes of thought, which he refers to as the 'superstructures of perception established by the exercise of intelligence'.[46]

Indeed, in Ibn al-Haytham's work, as Puerta Vílchez rightly says, aesthetic appreciation appears entirely circumscribed within the intuitive and sensitive cognitive field, and does not go through the demonstration of logic. It is an experience of knowledge free from subordination to ethics, logic and the religious reason to which medieval authors generally confine it. So, for the first time, in the Middle Ages, thanks to this Muslim thinker and physicist of Fatimid Cairo, the apprehending process of the beautiful acquires genuine autonomy within the entire range of cognitive practices, according to a thinking that we can call 'pre-aesthetic' relative to the specific modern science called 'aesthetics'.

To conclude, classical Arabic thought invested beauty with various significations, from the sublimely beautiful in the human person and yoked with ethics in Ibn Ḥazm's theory, to the phenomenologically modulated and classified beauty of Ibn al-Haytham to both opposed visions of the luminescent and intellectual beauty from the divine source of Ibn Sīnā and the beautiful structural order of the material world of Ibn Rushd. In a sense all kinds of beauty—logical, metaphysical, physical and ethical—are to be found in medieval Islam. An analogous remark can be made about the opposite concept, ugliness which equally presents many faces and various aspects associated with immorality, imperfection, disproportion, ignorance and disorder.

2

The Aesthetics of the Solomonic Parable in the Qur'an

The eye perceives the outer and the surface of things, but not their inner essences; moreover, it perceives only their shapes and their forms, not their real nature.

al-Ghazālī[1]

This chapter is a summary of the main thesis of my book *Le Piège de Salomon, La Pensée de l'art dans le Coran* (Solomon's Trap: The Thought of Art in the Qur'an).[2] It rests on a study of the aesthetics to be found in sura *al-Naml* (Qur'an 27:15–44) which describes the story of the visit of the Queen of Sheba to Solomon, the prophet-king. In the final episode of the story, Solomon invites the queen to enter his palace, the floor of which is made of glass or crystal. Mistaking it for water, the queen lifts up her skirts as she approaches to avoid getting them wet. Solomon corrects her mistake, declaring that the palace is made of glass. Thereafter, she realises that she is wrong and submits to Solomon's God:

She was invited to enter the court (*al-ṣarḥ*). When she saw it, she took it for a sheet of water, and uncovered her legs. Solomon told her: 'This is a court paved with tiles of glass.' 'O Lord,' she said, 'I have wronged myself, and I submit to the Lord of all the worlds with Solomon.'[3]

(Sura *al-Naml*, Qur'an 27:44)

26

This verse is a Solomonic parable, that is to say one of those sacred legends from which we can continually extract meaning as we discover new ways to approach it. In his book *Demonizing the Queen of Sheba*,[4] Jacob Lassner analysed this tale from an anthropological standpoint, underlining its obvious philosophical and religious adaptability starting from Judaic scripture up to the last hermeneutic developments in Islam. However, the royal double myth contains another important dimension within the whole monotheistic tradition—the aesthetic dimension—which appears as particularly significant in the Islamic imagination. In the light of modern semiotics, together with other new tools for understanding scriptural materials such as phenomenology, sura *al-Naml* shows the strength of this aesthetic dimension in the legend of Solomon and Bilqīs,[5] while revealing the existence of a specific conception of art emanating from the Divine Word itself. At least this is the idea I put forward in my book, by presenting the culturally determined viewpoint of a present-day observer, educated in the Western world and without religious involvement in the problematic question of the cognitive status of the Qur'an.[6]

Our aesthetic discussion rests upon evidence of a literary order. Indeed, beginning with its literal semantics, the verse provides us with an objective aesthetic element, namely the singular experience of one of the two protagonists on which the narrative is based. This experience consists of the mistaken visual perception by the Queen of Sheba of the mysterious glass device in Solomon's palace. An artefact in an architectural space, a human subject seeing, perceiving and experiencing this space through their own subjective sight: we do not need anything more to assert that the action described in the Qur'anic text constitutes an aesthetic experience in the world of visual forms, that of art and architecture. Such an observation supplies sufficient reason to think that, beyond the religious message, this verse communicates an aesthetic thought. By 'aesthetic thought' we mean precisely the category of knowledge which was epistemologically isolated by modern science in the West as a defined field, i.e. as an object of thinking *per se* with its own ontological principles and logic. Understood in this modern sense, aesthetics deals with the arts in general, and so with works conceived in order to be

at once beautiful, cognitive and expressive, which thus suppose an intellectual undertaking and a purely aesthetic conceptualisation beyond any functional purpose.[7] Within this category of thought, the aesthetics of perceptual forms possess a specific status because, being concerned with the material world, it implies the particular phenomenon of visual perception.

We will approach this problem along three distinct lines of enquiry. The first will consider the verse content in the light of the Solomonic mythology in general, through which the paradigmatic implications of the Qur'anic story for Islamic artistic tradition can be evaluated. Secondly, by defining the modalities of the aesthetic cognition of the parable through textual analysis, we will demonstrate that Solomon's floor of glass without doubt belongs to that class of objects called 'works of art'. Finally, we will provide evidence to show that the aesthetic cognition of the verse yields a truly practical application. This discussion has a broader purpose; namely a better comprehension of Islamic artistic creation itself.

To begin with, it is necessary to situate the Qur'anic passage within its cultural framework, that is in the context of its Solomonic mythology.

THE MYTH OF SOLOMON AS AN ARTISTIC PARADIGM

The myths relating to Solomon formed a powerful artistic paradigm in the Middle Ages as they do in modern times since, according to the monotheistic tradition, the king represents the archetype of royal patronage of arts, architecture and urbanism. This tradition indeed assigns to him the Temple and the royal residence in Jerusalem,[8] of course, but also, in the Islamic version of the myth, several actual places such as Palmyra in Syria, Persepolis in Iran and Kabul in Afghanistan, as well as some imaginary towns like the City of Copper depicted in the *Thousand and One Nights*. The prophet-king is equally famous for having ordered the building of luxurious baths[9] and for possessing various marvels, including a fabulous throne, a golden table, pearls, metalwork items and many other rare objects.[10] In brief, the mythic figure of Solomon represents not the artist as an individual, which corresponds to a modern Western concept, but rather the one who initiates artistic creation and

defines it by stressing its proper aesthetic and ethical values within the universal body of knowledge.

In other respects, one knows that within the monotheistic tradition, Solomonic mythology conditioned, or contributed to, the conceptualisation of many works of art. Formal and symbolic as well as iconographic references to it are numerous in Islamic and Christian arts and architecture, in European paintings and sculpture, from the Middle Ages to the Renaissance.[11] Within Islam in particular—the area of our study—the paradigmatic implications of the myth are evidenced in diverse artistic fields. In medieval and modern Islamic miniatures, scenes of the story of Solomon and the Queen of Sheba tale frequently illustrate the texts.[12] But there exists a more interesting manifestation of this referential phenomenon to sustain our argument, namely a representation of the story described in Qur'an 27:44 found in a Persian manuscript in the Freer Gallery, Washington, possibly originating from the thirteenth century. (Plate 1) This manuscript presents an illustrated version of the famous book *Ta'rīkh al-rusul wa'l-mulūk* (*History of the Prophets and the Kings*) by the great traditionist al-Ṭabarī (d.311/923). In it, the author offers an explanation of the glass feature and the illustration displays an image that corresponds exactly and literally to this. That is to say, the pictorial representation depicts every narrative detail mentioned by al-Ṭabarī following his own comprehension of the tale. It shows the two protagonists facing each other, in the midst of the glass architectural device containing real water and fish graphically recognisable to the viewer. The queen has hairy ankles according to the particular version of the episode that the traditionist provides as a clue for understanding the underlying meaning of the story.[13]

In fact, to fully comprehend the aesthetic function of the Qur'anic story, consultation of the Islamic exegesis of it is necessary. The various interpretations attempt not only to reconstitute the circumstances of the narrated 'event', but also to define the structure of the Solomonic artefact itself, clearly involving a debate of an aesthetic order. For example, another important medieval commentator, Tha'labī, who offers an opinion of the text close to that of al-Ṭabarī, reports in his book *'Arā'is al-majālis*:

When she arrived in Solomon's presence, she was told: Enter the court! The reason for this was as follows: when Bilqīs drew near in search of him, Solomon ordered the satans to build him a court (ṣarḥ). That was a palace (qaṣr) of glass resembling white waters in which they placed real water stocked with fish beneath the floor. Following that, he had his throne placed along the central axis (fī ṣadrihi). Then, he sat, with birds, jinn and humans arrayed around him.

He ordered the construction of the court because the satans said to one another, 'Whomsoever God has made subservient to Solomon, He has made subservient according to his wish. Bilqīs is the Queen of Sheba. If Solomon marries her, she will give him a son, and our servitude to the prophet will forever be unbreakable'. Hence, they wished to incite him against her. And so they said, 'Her feet are like the hooves of a mule and she has hairy ankles, all because her mother was a jinnī'. Solomon wished to learn the truth of this and to look at her feet and ankles. So he ordered the building of the court.

Wahb b. Munnabih related: Solomon built the court only to test her intelligence and understanding. Thus, he presented her with a puzzle just as she did him in sending the lads and maidservants in order that he might distinguish between the males and females. When Bilqīs arrived, she was told: Enter the court! When she saw it, she reckoned it to be a pool most of which was filled with water. And so she uncovered her ankles to wade through the water on her way to Solomon. Solomon gazed at her. Behold! She had the most beautiful ankles and feet that any human could have, but her ankles were most certainly hairy. When Solomon saw that, he turned his eyes from Bilqīs and called out to her that it was a court made smooth with slabs of glass and that there was no water on the surface ...

Now, Solomon called upon her to become a Muslim. Having witnessed what had happened concerning the hoopoe, the gifts, the messengers, the throne, and the court of glass, she responded affirmatively, saying: 'My Lord! I have wronged myself through unbelief. I submit through Solomon to Allah, the Lord of the Universe.'[14]

This text, like many other commentaries on Qur'an 27:44, denotes that, by virtue of its structurally ambiguous appearance, Solomon's glass-

work constituted in the eyes of a medieval thinker an object open to interpretation concerning its specific character and perceptual qualities: the transparency and flatness of the material, its white or green colour, the apparent presence of living sea creatures, the real water beneath it and so on. In our opinion, this discussion reveals the deep aesthetic resonance of the Solomonic palatine theme.

Effects of this aesthetic resonance can be perceived, as we said above, in the realm of Islamic architecture, mainly in royal buildings mentioned in historical and literary sources, whether they are the imaginary creations of poets or real monuments described by the historians. (Plate II) Thus, the historical sources tell us that in al-Andalus in the eleventh century, the sovereign of Toledo, al-Ma'mūn, ordered the building of a so-called 'crystal palace'. Even if this building is only known through written accounts and not through archaeological evidence, the detailed descriptions of it show the substantial paradigmatic influence of the Qur'anic story on the conceptualisation of Islamic palaces, at both the aesthetic and the symbolic level. For example, in *Nafḥ al-Ṭibb*, the sixteenth-century historian al-Maqqarī indicates that in the middle of the Andalusian palace an impressive domed structure was erected. It was made of glass inlaid with gold and surrounded by a sort of watery curtain.[15] Mirroring the sacred image of King Solomon sitting in his transparent palace, al-Ma'mūn would sit enthroned in this sophisticated structure without getting wet with the water flowing around him. This aesthetic arrangement for producing optical effects, based on the typical alliance of water and glass and of fluid and solid, refers directly to the mythology of Solomon and precisely to the crystal pattern named 'ṣarḥ' in Qur'an 27:44. The Moroccan Saadian sovereign, al-Manṣūr al-Dhahabī, again took up this tradition by building in his residence of al-B'ādia in Marrakesh, a pavilion also called the 'crystal palace'.

In Islamic literature especially, references to Solomon's glass palace as an ideal model are plentiful. For instance, in al-Buḥturī's *Dīwān* (third/ninth century), a poem sings the praises of a big pool in the royal house by evoking the experience of the ṣarḥ by the Queen of Sheba:

It is as if Solomon's *jinn* (spirits) had built it from carefully studied plans. And if the Queen of Sheba would cross it, she would say, 'It resembles the floor paved with slabs of glass'.[16]

A poetic inscription in the Alhambra, composed by Ibn Zamrak for the so-called Mirador of Lindaraja, makes another significant allusion to the Qur'anic parable. (Plate III) In this case the poem appears inscribed in a building which is still standing, and again compares the Naṣrid architecture with the Solomonic pattern. Specifically it uses the metaphorical image of the palace as a watery place:

> This is a palace of transparent crystal, those who look at it imagine it to be a boundless ocean.
> Indeed, we never saw a palace more lofty than this in its exterior, or more brilliantly decorated in its interior, or having more extensive apartments.
> And yet I am not alone to be wondered at, for I overlook in astonishment a garden, the like of which no human eyes ever saw.[17]

As in the Qur'anic verse, the inscription gives the place the name *ṣarḥ*, meaning the royal house as a whole or a specific feature within it, perhaps the garden or a fountain (mentioned above) which one could contemplate from the *mirador*. It is difficult to say with any certainty. Nevertheless, the poem clearly links the existing Naṣrid architectural pattern to the glasswork of Solomon by specifying its peculiar decoration with the Arabic term *zujāj*. Indeed, the Qur'an designates this material with the word *qawārīr* instead of *zujāj*, but both terms refer to a product made of glass. In addition, the poem appeals to the Qur'anic figure of speech of the 'boundless ocean', *lujja*, and thereby superimposes the textual picture of the *ṣarḥ* upon the poetic image of the Naṣrid palace.

Equally in the East of the Muslim world, one finds some evidence of this artistic modelisation process stimulated by the Solomonic narrative. Some glass tiles, which were designed to cover floors, were extracted from the remains of a medieval residence at Raqqa in Syria. According to Oleg Grabar, these ornaments probably manifested an attempt to

imitate or to create an aesthetic evocation of the Solomonic pattern in Qur'an 27:44.[18]

These selected examples demonstrate the paradigmatic influence of the double myth of Solomon and Bilqīs on the Islamic artistic conceptualisation, and illustrate the cultural phenomenon we call 'the Solomonic aesthetic consciousness'. This phenomenon occurs in the broad cultural framework of the monotheistic tradition, but it seems to acquire more importance in the Islamic world, probably because of the great status accorded to Solomon and his stories in the Qur'an itself. Verse 27:44 and several others quoting the king's marvels and architectural works, such as Verse 13, sura *Sabā* (Qur'an 34) which mentions metalwork items and various artefacts made by Solomon's *jinn* (spirits) constitute *stimuli* of this aesthetic consciousness. Consequently, we can assume that these verses fulfil, in one way or another, a global aesthetic cognitive function. However, from this point of view, it is undoubtedly the passage of Qur'an 27:44 which conveys the most powerful resonance and goes deepest in the rhetorical instrumentation of the Solomonic artistic mythology. Let us now analyse this aspect of the parable, the study of its own semantics.

THE AESTHETIC COGNITIVE FUNCTION OF QUR'AN 27:44

That Qur'an 27:44 relates a parable means that the aesthetic elements it contains are not directly explained but conveyed through metaphor which is precisely the scenography of the entry of the Queen of Sheba into Solomon's palace. In order to grasp these aesthetic elements, we have to decipher the text like a rebus and, first of all, to examine its semiotic structure.

Transmitting its religious message by means of metaphorical language, the verse presents a double semiotic structure signifying at both the manifest and the hidden levels.[19] Through the narrative, corresponding to the manifest or literal level, the text aims at demonstrating in concrete and easily understandable terms the abstract religious truth corresponding to the induced or hidden level of significance. In other words, thanks to its rhetorical power, the manifest meaning gives to the

induced meaning a maximal cognitive effectiveness. Relative to this pe-
culiar signifying system, the semantic configuration of the Qur'anic
passage stands out in the following terms:

At the literal level, by showing the queen making a mistaken gesture
in front of the king who corrects her behaviour, the story basically draws
upon a Manichaean narrative scheme: one protagonist is wrong, the other
right; one knows, the other is in some way ignorant. This scheme gener-
ates a second at the hidden level or conveys it symbolically according to
the metaphorical principle, namely a scheme of positive and negative
religious values that sets the believer in opposition to the unbeliever;
the divine wisdom given to prophets as opposed to mere human powers;
victorious Islam to paganism and any form of unbelief. This is the semi-
otic structure of the verse, its logical foundation. From this structure
flow a complex stream of literal as well as induced cognitions. Among
them, cognitions of an aesthetic order logically hold an important rank
insofar as the metaphorical support is the narration of a visual experi-
ence. Simply put, the verse dictates the correct rules to follow, which
constitute abstract concepts of faith, with concrete aesthetic terms that
one can mentally visualise, more precisely with an aesthetic demonstra-
tion. Therefore, it seems plausible to argue that this demonstration
possesses in itself a truly doctrinal value by virtue of the religious princi-
ple it expresses. The various aesthetic cognitions it produces are
consequently open to exemplification and modelisation, given that eve-
rything told or signified in the Qur'an, by definition, exemplifies and
modelises.

This aesthetic demonstration is based on two elements named and
described with the minimal but powerfully rhetorical language that char-
acterises the Qur'anic speech: the first is an object, the Solomonic work
of architecture; the second is an action which consists of the experience
of this object, namely the entry of the Queen of Sheba. The text men-
tions the first element once, in the sentence formulating the invitation
to penetrate the palace: '*qīla lahā udkhulī al-ṣarḥa*'. Here the exact mean-
ing of the word '*ṣarḥ*' raises problems. Within the narrative context, we
can only be sure that it comprises an architectural space one can enter
and walk upon, suggesting at least a floor if not a whole room or building.

Neither the parable, nor the exegesis that proposes various linguistic interpretations,[20] allows us to set a firm structural determination of the object in terms of two- or three-dimensionality. It could refer equally to a palace, a tower, or a room, or to a simple floor or courtyard. Consequently, the term '*ṣarḥ*' remains open to discussion. With regard to our argument, we will admit that potentially it carries all of these significations, definitely meaning an architectural feature in the framework of Solomon's residence.

Further to the invitation, the verse mentions once again the word '*ṣarḥ*' in the Solomonic sentence: '*innahu ṣarḥun mumarradun min qawārīra*'. But in addition, it defines it quite accurately by indicating the main constitutive aspects of its artefactuality. Firstly, the sentence points out the nature of the material out of which the architectural pattern is made, *qawārīr*, meaning glass or the finest kind of crystal.[21] However, unlike *zujāj*, the generic term that designates glasswork and appears for example in sura *al-Nūr* (Light), *qawārīr* conceals the notion of a process transforming the primary substance. From this point of view, we are again confronted by uncertainty. Several Muslim authors, like al-Bukhārī, speak about broken glass in small pieces, almost a powder, while others interpret the word as 'tiles' suggesting a more sophisticated technique of glasswork that involves cutting the raw material into squared units. In any case, the common informative element positively linking these different interpretations of the word remains that the glass is modelled into a particular shape, repeated regularly in order to form a homogeneous set.

Secondly, using the word *mumarrad* specifically, the Solomonic sentence is precise in describing the technique with which the glass area is applied in relation to the space it covers, whether it concerns a court or a room. Frequently translated as 'paved' or 'made smooth with', *mumarrad* means not only that the material itself displays a sort of regular aspect, but equally, that in the way it is modelled is concealed an aesthetic notion of perfect isotropy that could be qualified as 'geometrical'. In fact, *mumarrad* designates the exact process of covering a space without leaving any gaps, an 'all-over mode' of applying a material to one plane, like paving a floor or panelling a wall or any type of wainscot. Each glass

35

fragment appears equal to all others and is inlaid at the same depth in order to give a quality of smoothness to the surface. Only a geometrical principle could produce such a setting and bring it to a perfect finish.

Finally, the semantic association of the words *mumarradun min qawārira* induces a range of perceptual qualities and material properties that draws a true picture of the *ṣarḥ*, a sort of textual 'icon'. This icon 'represents' an architectural feature one can enter, made with an overall glass setting, transparent, bright, white or green, isotropic, with a perceptible linear design generated by a process of assembling glass fragments, these fragments showing a particular shape produced by cutting or breaking the applied substance.

There is yet another aspect of the text that reinforces the outlines of this image of the Solomonic feature, which comes not from the linguistics but from the narrative semantics of the verse. This 'imaging information',[22] suggested by the perception of the *ṣarḥ* by the Queen of Sheba, is the resemblance of the *ṣarḥ* to a mirror of water or a pool. This phenomenon of likeness does not signify that the *ṣarḥ* artistically reproduces, represents or symbolises an aquatic element. In other words, it does not signify that water constitutes the subject of the Solomonic device as a work of art, a theme of its design or its iconography. We would have needed a different set of explicit semantics to assert that there exists a representational link between the glasswork and the reflecting pool it resembles. Objectively, the available narrative content, especially the assertive phrase pronounced by Solomon, 'this is a court paved with tiles of glass', implies that only a perceptual likeness binds both entities, given that the aesthetic concept of similarity is absolutely distinct from the aesthetic concept of representation.

Once again, such resemblance allows one to deduce that the *ṣarḥ* provides visual analogies with natural liquid, to the point that it appears as an aesthetic isomorphism of a water plane. Obviously, such a visual isomorphism is not an accident, nor does it proceed at random but results from a conscious act, being an integral part of the conception and the conceptualisation of the architectural device. This act constitutes the creative intention that initiates the glasswork, given that any work of art is a 'pattern of intention' according to the meaningful expression coined

by the philosopher of art Michael Baxandall.[23] More accurately, the manifest intention in the aesthetic system of the ṣarḥ is to sharpen the close similarity between glass and water which serves the rhetorical purpose of the story. In order to fulfil this project, the watery theme has been selected as a formal model for building the artefact, the physical analogy being both the formal evidence of this generative process (taking water as a model) and the manifestation of the intention (making the artefact look like water). And because it was selected as a model, the aquatic element forms, in the aesthetic language of the glasswork, not a subject, nor an objective iconography, but a reference.

The concept of reference in the visual arts is governed by a specific logic that distinguishes it from the concept of subject. If the latter takes full part of the ontological status of the artistic object it specifies as a constitutive element, the former constitutes a *potentiality*, that is to say that basically the reference is a *potential* element of the visual language. So logically, the creative process of inspiration linking the model to the glasswork does not necessarily imply that the reference to water still constitutes an active element within the artefact aesthetic system, a criterion for understanding, experimenting and enjoying it. Clearly, the ṣarḥ conceals the ability to lead the viewer to think of water because it contains in its own system of visual signs the potential reference to it that manifests the initial modelisation process. However, it may equally be perceived as what it is in absolute terms, 'a court paved with tiles of glass', as Solomon himself declares.

These are the main terms of the definition of the Solomonic device, i.e. the first element of the aesthetic demonstration in Qur'an 27:44. Before analysing the second element, the experience itself, it is tempting to compare the textual picture of the ṣarḥ with some existing Islamic works of art.

Actually, the Qur'anic depiction has given rise to various aesthetic principles that are widely applied in artistic forms and architecture in Islam. The glass pattern shares with ceramic, stucco or marble arrangements in monuments, especially in geometrical decoration, the same plastic system of covering a functional space in a regular way with a chosen material, modelled according to selected shapes. Such aesthetic

organisation corresponds with what we usually call 'ornament', forming an 'overall' decoration of combined and repeated elements that adorn a wall, floor, arch or the like. A determined symbolism or representation cannot be identified in these ornaments, but some of them definitely conjure up in our mind pictures of recognisable things, textiles, flower gardens, constellations, etc., a range of objects that we can assume have inspired the pattern without necessarily forming a representational subject in its visual semantics.

Other ornaments do present a concrete theme inspired by nature, such as the various types of flowers found in Ottoman ceramics or textiles. Nevertheless, in many of these cases, the iconography is but a pretext for the composition of a decorative set that lends itself to the play of free imagination, rather than proposing a true representation which assumes necessarily that the legible pattern conveys by itself the principal meaning of the work of art. Nor does a literal reading of this naturalistic theme, that is the objective recognition of its real identity, constitute the absolute condition to enjoy or appreciate the ornament animated by it. This type of figuration keeps the aesthetic status of a potential reference, in this case a reference to natural patterns; but it can still be apprehended strictly as a perceptual proposition, that is to say as gathered forms, with various physical properties, lines, colours, movement, light, and so on and so forth. This follows the same rules as those of the work of Solomon which can be perfectly understood as the simple aesthetic proposal stated in the phrase, 'a court paved with tiles of glass'.

We now reach the second point of our argument, namely, the experience of the Solomonic feature by the Queen of Sheba, the other element of the aesthetic demonstration that expresses the religious thought of the verse. The best way to clarify the mechanism of this experience is again to focus upon the logic of the narrative. Upon entering the palace, the queen sees water instead of glass, the natural element instead of the artefact that was built after it. This mistake reveals that the aesthetic isomorphism characterising the perceptual structure of the ṣarḥ, raises an acute visual issue: the universal issue of the dialectic tension generated by the process of resemblance between works of art and their models in nature. Works of art display apparent likeness with natural objects

because of the fundamentally imitative character of the artistic creation, following the Aristotelian concept of *mimesis*, 'imitation'. In this case *mimesis* must be understood in its generic significance, not in the specific sense of 'realistic copy' or 'reproduction' of the real. Sometimes art aims to create for itself a totally natural visible aspect as an alleged substitute for the natural model.

In the Qur'anic story, what Solomon intended was to subject Bilqīs to some trials in order to reveal her shortcomings. He therefore set her the challenge of responding to this difficult issue of *mimesis* in art, inviting her to enter his palace in order to test her capacity to understand and resolve the complex aesthetic dilemma posed by the enigmatic crystal marvel. Accordingly, the terms of the visual perception of the marvel constitute the response to the issue raised by virtue of its aesthetic character. As a result the queen makes a substitution of water for glass, that is to say she confuses reality and fiction by basing her judgement only on appearances, namely, formal analogies. This means that the process of resemblance has provoked in the sovereign's mind a loss of visual consciousness, removing her ability to distinguish art from nature, and by extension, the false from the true. In terms of phenomenology, in the specific framework of visual aesthetics, we call this process an optical illusion. Consequently, we can state that the second element of the aesthetic demonstration metaphorically conveying the religious meaning of the verse is positively an optical illusion. Immediately this statement raises the following question: what are the cognitions, at both the literal and the induced level, that follow from the scenario of the Queen of Sheba's visual confusion? As they form a complex knot of thoughts, we will point some of them out by focusing on aesthetic notions.

SOME ASPECTS OF AESTHETICS IN THE PARABLE

As a metaphor, the optical illusion experienced by Bilqīs signifies through images a certain conception of the artistic problem of *mimesis* and, first of all, its conception in terms of values. Thus one must wonder whether the positive or the negative value of this aesthetic phenomenon is relevant to the Solomonic story content. In theory, as concerns the vision

and experience of art, the aesthetic value of an optical illusion changes according to the cultural context or is culturally determined. In fact, the phenomenon can be understood as the positive result of the perception of a perfectly mimetic masterpiece, a so-called *trompe l'oeil*, provoking pleasure and aesthetic satisfaction. For example, Pompeiian parietal paintings were deliberately composed to show illusionistic reproductions of landscapes and open spaces in architecture. Similarly Baroque art often produced visual effects provoking perceptual confusion and deliberately subverting reality through fiction. However, an optical illusion may also create trouble and can be considered purely as a mistake or a defect of visual judgement causing unpleasantness in a situation where such confusion is unexpected.

In the case of the Solomonic story, by simply considering the Queen of Sheba's gesture in uncovering her legs in front of the king, which precedes her spectacular conversion, we can postulate that the optical illusion is shown under this last negative aspect, i.e. as a manifestation of unconsciousness. The mistake made by Bilqīs expresses, at the hidden level of the text, her ignorance of the religious truth and, in a wider perspective, the lack of knowledge that characterises all pagan people. In short, in the content of the verse, the optical illusion forms a metaphor for paganism and is consequently invested with a negative artistic value. This particular cognition delivers a deep thought concerning the aesthetic issue to which the phenomenon of illusion responds, the relationship between art and nature based on the concept of *mimesis*.

The optical illusion narrated in the Qur'an manifests the strong dialectic tension that animates this relationship. However, shown as a mistake, it involves a particular philosophical approach to this relationship, for it obviously means that there is no way to confuse one entity with the other, the artefact and its model, art and nature, despite the phenomenon of resemblance. This phenomenon only proves the primal process of inspiration leading to artistic creation. Nature, symbolised in the verse by water, belongs to divine creation, and art, symbolised by the Solomonic *ṣarḥ*, belongs to human creation. The former is the aesthetic source of the latter, but this fact does not render possible the permutation or substitution between them. Both entities are absolutely distinct in

essence, and a failure to grasp this ontological truth is a serious error. Appearances are not realities, they are only a part of them.

This analysis has only demonstrated the immediate aesthetic sense of the metaphor of the optical illusion in the Qur'anic parable. But by relying on this sense, we can deduce that the primal aesthetic cognition of the verse dealing with the issue of the relationship between art and nature is an absolute *non*-recognition of imitative or mimetic artistic creation, so-called *trompe l'oeil*. Art imitates but cannot reproduce nature and it is neither possible nor legitimate to attempt to interchange the two. Indeed, as we know, mimetic art was never really customary in Islam after the formative period under the Umayyads (41–132/661–749).[24] In other respects, this fundamental problem of art and nature raises a whole series of other aesthetic reflections or interrogations to which the verse provides answers or solutions. This complex issue is the subject of my book *Le Piège de Salomon*.

Finally, Qur'an 27:44 contains sufficient evidence to merit the conclusion that it is vested with an aesthetic cognitive function and that it has exerted a paradigmatic influence on Islamic art and architecture. This is apparent from its semantics, through the artistic modes it suggests, the image of the glasswork recalling similar aesthetic principles in the reality of the works of art. There is also the evidence of the cultural context in which numerous references to the story of Solomon and the Queen of Sheba can be found. Actually, our discussion has taken its standpoint from the perspective of a tradition deeply marked by a Solomonic aesthetic consciousness which reveals itself through inscriptions, literary quotations and evocations of the king's tales, as well as by an ancient habit of princely representation and symbolism involving his artistic mythology—a cultural habit which seems to have been established since pre-Islamic times and continued into the modern period. For the future, it will be necessary to grasp the precise relationship emanating from these aesthetics contained in the Islamic scriptural sources and the existing works of art themselves, in order to arrive at a better understanding of artistic practice. Nevertheless, we must take into account the fact that the modalities of cognitive interaction between text and visual form in Islam remain difficult to decipher.

3

Understanding the Comares Hall in the Light of Phenomenology

What a great principle of the dream of intimacy a vaulted roof is!
It constantly reflects intimacy at its centre.

<div style="text-align: right">Gaston Bachelard[1]</div>

This chapter proposes a new aesthetic interpretation of the so-called 'Comares Hall', or 'Hall of the Ambassadors', in the Alhambra—a richly decorated room, crowned by a spectacular wooden dome, that was used for audiences and receptions. (Plates IV, V, VI) This interpretation rests on a specific problem concerning the Naṣrid palace-complex, that of representation. Our discussion takes as its starting-point the following argument: there is no direct representation in the Alhambra, except for a few vaults and parietal figurative paintings that constitute added foreign and secondary elements in respect of a general visual configuration fundamentally dominated by abstract geometrical ornaments. The aesthetics of the Alhambra consist instead of a dynamic system of visual and textual metaphors, arising from an abstract design in conjunction with inscriptions, a system that conditions the experience of the building at both the perceptual and cognitive levels. Our purpose therefore is to show how the Comares Hall works as the most significative application of this system within the entire Naṣrid complex, i.e. as a visual metaphor,

specifically through phenomenological analysis. But it is necessary first to review the overall problem of representation in the Alhambra.

AN OVERVIEW OF THE PROBLEM OF REPRESENTATION IN THE ALHAMBRA

Aesthetic studies on the Alhambra essentially rely on one source, the semantic content of the decorative inscriptions which appear particularly abundant in the building relative to what we know about Islamic palaces in general.[2] However, these inscriptions and architectural features are articulated in a significant way that shapes the aesthetic system of the entire complex. Altogether, the texts, including Qur'anic quotations, poems and pious expressions,[3] present an imagery full of pictures and poetic metaphors that create a highly animated textual world coexisting with the visual world of the architectural forms. Inversely, the latter are dominated by highly abstract decoration, in lavishly expanded geometrical designs. In this textual world, drawn by famous poets from Granada such as Ibn Zamrak and Ibn al-Khaṭīb, the shining figure of the sultan illuminates the star-studded canopy of the heavens, while the paradisal palatine environment spreads out around him, resounding with the voices of its personified architectonic features that sing the praises of the site and its glorious owner. In this way, the whole building in a sense 'speaks' through the inscriptions, and seems like an animated theatre filled with living expressions which address the visitor, coloured with a multiplicity of ornate figurative poetic images. The location of each inscription was carefully chosen in order to fit into the morphological scheme as well as the function of the architecture. Let us quote passages from some decorative poems.[4]

The Hall of the Two Sisters contains long poems from which these verses are taken:

> The capitals [of the columns] contain all sorts of rare wonders so that proverbs [composed about them] fly in all directions and become known throughout.
> In it there is burnished marble whose light has shone and thus illuminated the darkest shadows remaining in the gloom ...'
> 'Here is the wonderful cupola, at sight of whose beautiful proportions all

other cupolas vanish and disappear,

To which the constellations of the Twins extend the hand of salutation,
and to converse with which the full moon deserts her station in heaven.

Nay, were they both to abide here in its two aisles, they would hasten to
pay it such an homage as would satisfy all the neighbours around.

No wonder then, if the stars grow pale in their high stations, and if a limit
be put to the duration of their light.

Here also is the portico unfolding every beauty. Indeed, had this palace
no other ornament, it would surpass in splendour the high region of
the sky.

For how many are the gorgeous robes in which thou, O Sultan, hast attired
it, which surpass, in brilliancy of colour, the vaunted robes of Yemen!

To look at them, one would imagine them to be so many planets revolving
on the arches of this court as on their orbits, in order to throw in the
shade even the first rays of morning.

Here are columns ornamented with every perfection, and the beauty of
which has become proverbial,

Columns which, when struck by the rays of the rising sun, one might fancy,
notwithstanding their colossal dimensions, to be so many blocks of
pearl ...

Between me and victory the closest relationship exists; but the most striking
resemblance between us two is the splendour we both bear ...

In one niche, from the same room, is inscribed:

Praise be to God!

Delicately have the fingers of the artist embroidered my robe,
after setting the jewels of my diadem.

People compare me to the throne of a bride; yet I surpass it in this, that I
can secure the felicity of those who possess me.

If any one approach me complaining of thirst, he will receive in exchange
cool and limpid water, sweet without admixture.

As if I were the bow of the clouds where it first appears, and the sun of our
Lord Abu'l-Ḥajjāj ...

On the portico preceding the throne hall in the Comares Tower, one
also finds the following poem:

Blessed be he who has entrusted you with the command of his servants

44

and who through you exalted [the world of] Islam in benefits and
 favours;
And how many infidel lands did you reach in the morning only to
 become the arbiter of their lives in the evening!
You put on them the yoke of captives so that they appear at your
 doorsteps to build palaces in servitude;
You conquered Algeciras by the sword and opened a gate which had
 [until then] been denied to our victory ...
O son of eminence, prudence, courage, and generosity, who has risen
 above the most brilliant stars,
You have risen on the horizon of your kingdom with mercy to dissipate
 the shadows of tyranny,
You have secured the branches from the blowing wind and you have
 frightened the stars in the vault of heaven;
If the flickering stars tremble, it is from fear of you, and if the branches of
 the willow bend, it is to give you thanks.

Then, the small niches at the entrance of the Hall of La Barca contain
this inscription:

I am [like] a bride in her nuptial attire, endowed with beauty and
 perfection.
Contemplate [this] ewer to understand the full truth of my statement;
 look as well at my crown and you will find it similar to the crown of the
 new moon;
Ibn Naṣr [Muḥammad V] is the sun of this heaven in splendour and in
 beauty;
May he remain forever in [this] high position without fearing the time of
 sunset ...

These highly rhetorical statements, invested with the objective of sing-
ing the praises of the building and its princely owner through lively
figurating imagery, have led many observers to interpret the art of the
Alhambra as a direct visual representation of the inscriptions' content,
seeking absolute proof of this representational system in its architec-
tural and decorative forms. Nevertheless, this system turned out to be
not so easy to prove, by virtue of the fundamentally abstract art that
characterises almost all Naṣrid architecture, except for a few figurative

45

paintings and, possibly, the ambiguous disposition of the Court of the Lions. As a result, the art of the palace has been categorised under the specific representational concept of the visual symbol.[5] The terms of this interpretation can be summarised by the following aesthetic axioms: the celestial and cosmic themes of the inscriptions are translated literally into a stellar geometry, consequently understood as a symbolically astral and heavenly pattern; the Court of the Lions constitutes a representational symbol of the Islamic Paradise described in the Qur'an, or even, according to certain opinions, as a true three-dimensional image; and finally, the Comares Hall forms a symbolic image of the seven Islamic heavens that the Qur'anic inscription (sura *al-Mulk*) mentions beneath the ceiling.[6] Do the visual forms really formulate and mean, in matter, what the inscriptions say in words, thereby conforming with traditional rules of representation?[7]

Given that visual symbols are in many cases enigmatic, i.e. they mysteriously hide their meaning by denoting or representing their object without describing it, they allow, in a sense, uncertainty in the defining of their exact function. Indeed, since, following Ludwig Wittgenstein's *Tractatus Logico-philosophicus* (4–466), 'To a definite logical combination of signs corresponds a definite logical combination of their meanings',[8] it may not be untrue to say that the architectural features of the Alhambra symbolise, in universal terms, the different topics dealt with in the inscriptions. The real difficulty arises when, in order to develop this idea further and to give it more argumentative substance, scholars explain this general or vague phenomenon of symbolism by binding forms and texts through a particular, literal type of correspondence. And while trying to argue by referring to the specific principle of symbolism according to which defined symbols represent defined objects (in this case defined visual symbols for defined textual references), the full interpretation is no longer valid.

In fact, when one draws the aesthetic parallel between the Alhambra's various decorative features and its epigraphy, one is immediately struck by a discrepancy in terms of style and rhetoric. While the predominant proposition of the visual matter is geometrical abstraction, namely all of the decorative networks, conversely the parietal texts display an intensely

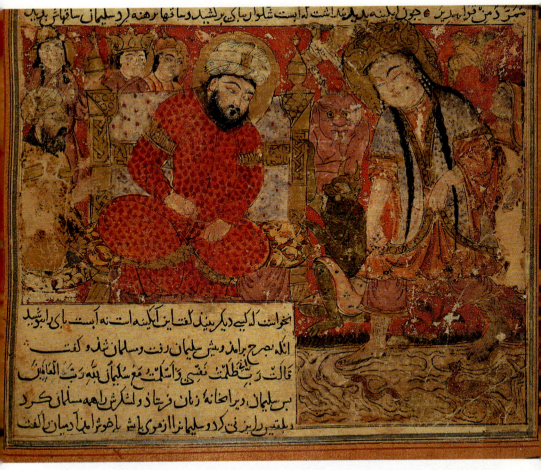

I ABOVE. King Solomon and the Queen of Sheba from a manuscript of al-Ṭabarī's *Ta'rīkh al-rusul wa'l-mulūk*

II BELOW. The Great Mosque, Aleppo, Syria, 11th-12th century CE

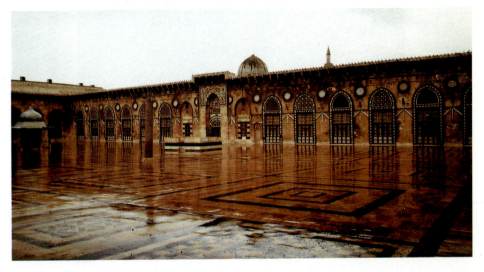

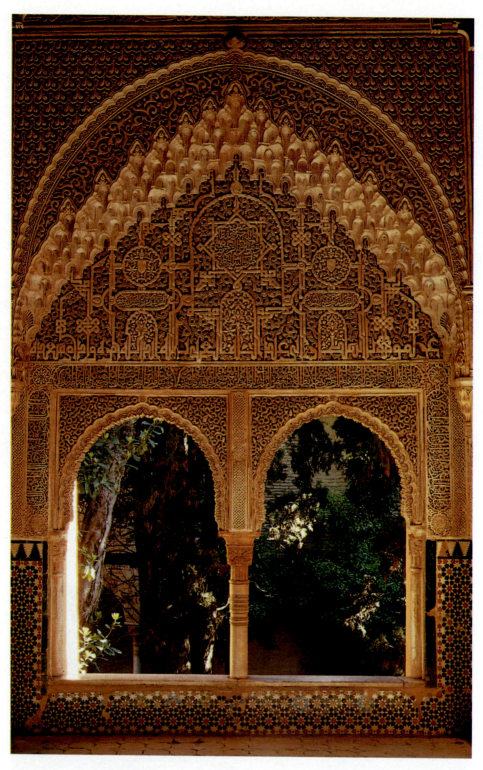

III The Mirador of Lindaraja, Alhambra, 14th century CE

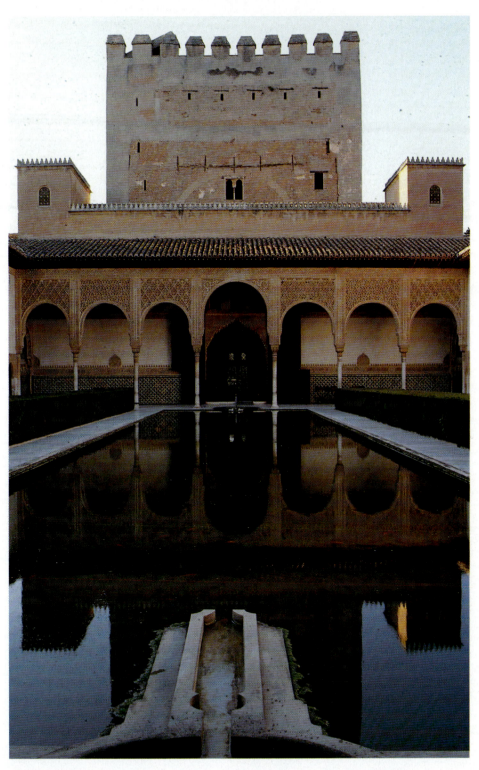

IV The Comares Tower and the Court of the Myrtles, Alhambra

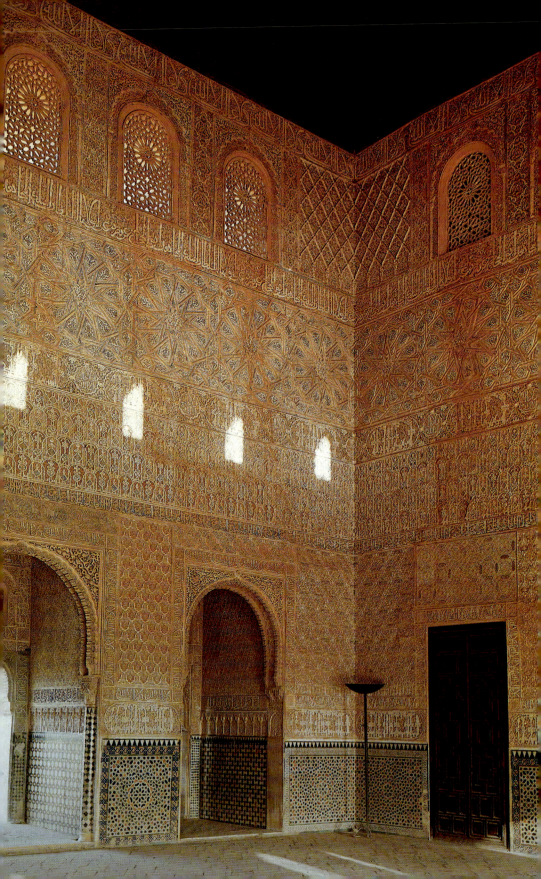

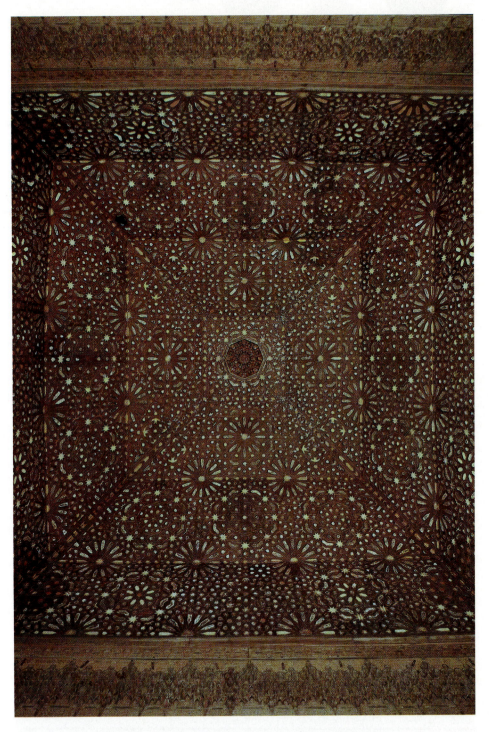

VI ABOVE. The ceiling of the Comares Hall, Alhambra

V OPPOSITE. Inside the Comares Hall or Hall of Ambassadors, Alhambra

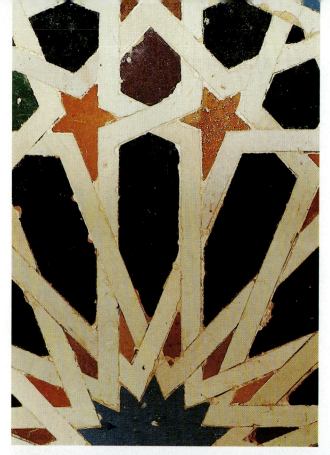

VII LEFT. Polychromatic
ceramic geometrical star
pattern, Alhambra

VIII BELOW. *Getty Tomb*,
Frank Stella, 1959. Black
enamel on canvas

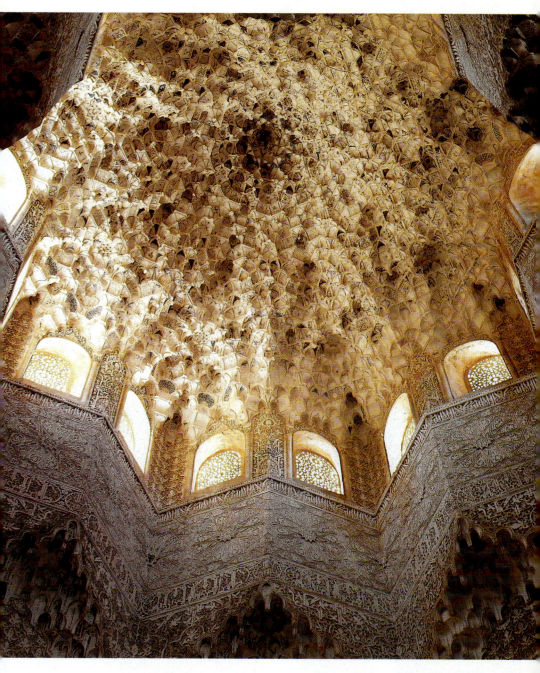

IX Cupola of the Hall of the Abencerrajes, Alhambra

X LEFT. Cupola of the Great Mosque of Isfahan. Saljuq art of the 12th century CE

XI BELOW. Court of the Lions, Alhambra

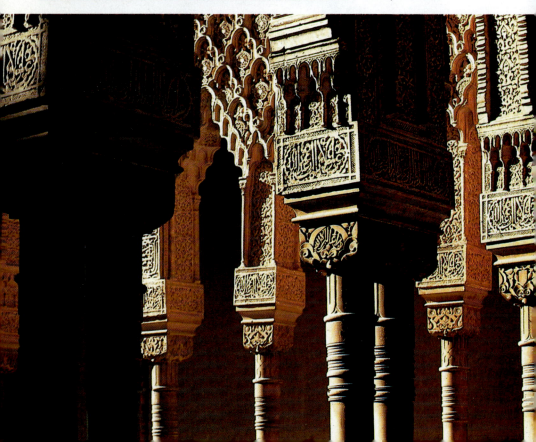

vital literature. Consequently, the type of connection proposed by scholars is very difficult to establish. First of all, the decorative features, the figurative frescoes and vault paintings, from which one would expect to find clear representational articulation relative to the texts, do not reveal any meaningful links. The anthropomorphic motifs shaping the apologetic poems are totally absent from these figurations. This is especially true of the royal epiphany, the central poetic theme that depicts the sultan's radiant face looking like a sun amidst constellations, which significantly lacks the portrayal of kings or nobles, apparently to avoid showing the monarch as an individual.

Furthermore, in no way can any of the remaining patterns claim to be pictorial expressions of the inscriptions' content. The only possible connection with the epigraphic iconography concerns, very loosely, the common affiliation with the royal theme of court life shared by both. Otherwise, the paintings have no significance other than that of their own iconography, i.e. as representations of gathered dignitaries, enigmatic scenes of hunting or people grouped near to a medieval castle and armed soldiers on horseback. Moreover, let us remember that some of them were painted by foreign artists from the Christian world; not surprisingly considering that the Naṣrid civilisation was deeply penetrated by the neighbouring Latin culture.

In other respects, whilst these figurative works do not occupy very important sites in the architectural distribution, they nevertheless provoke a curious visual contrast with the surroundings that depend entirely upon geometrical abstraction. Clearly they have no particular semantic or aesthetic relationship with either the parietal texts or the decorative geometry. The result is that they appear as features that were added, grafted on to an independently conceived structure, without being integral to it. If they were to disappear from the building, the work of art would not lose an atom of its meaning and its aesthetic balance would not be changed.

The same observation applies to the genuine symbolic visual language that the Alhambra incorporates in its ornaments. This includes heraldic and prophylactic patterns, such as the escutcheon, the key and the hand (*khamsa*), some of them again borrowed from the Christian arts.[9] This

symbolic language contains a very reduced vocabulary and cannot therefore be considered as an element of great significance within the overall semantic system of the Naṣrid monument. To summarise, all of these representational works form a discrete and secondary aesthetic field in respect of the main one—the ornamental layout.

Nor is there in the ornamentation any precisely defined sign or symbol which would correspond to the textual theme in a way that would lead to a direct representational identification between both terms of the aesthetic conception of the palace. It is as if the scriptural imagery, so full of life, dissolved upon contact with matter while trying to acquire corporeal shape; as if it was disembodied and absorbed by the linear abstract network of the plane of geometrical design.

The only patterns that could present, in some sense, such a matching relationship are the starry geometrical drawings. (Plate VII) On the ceilings, the wall panels, the doors and almost everywhere throughout the building, one finds concentric circles of stars that conjure up pictures of constellations, echoing the stellar images depicted in the inscriptions. However, while attempting to visualise these stellar images in the geometrical ornaments, a strange phenomenon occurs. The images become less and less defined, tending to loose their outlines and ornate structure by virtue of the continuous radiating outwards of the geometry in the architecture, often conveying a principle of transcendence. This phenomenon continually prevents a perfect adequation and the concrete localisation of textual iconology in the formal territory. This leads to the impossibility of accurately pinpointing the supposed visual symbols thus allowing a kind of vagueness to float between the two aesthetic fields. In this way, even the geometrical theme of stellar polygons fails to sustain the hypothesis of objective representational articulation between the texts and the architectural devices.

Finally, this hypothesis does not solve the problem of a discrepancy which becomes sharpened when we attempt to make a literal connection between the architectural configuration and the parietal texts. Such a discrepancy involves another important aesthetic phenomenon to be found in the Alhambra: the autonomy of the two artistic spheres of architectural forms and inscriptions. If they clearly combine with each other

in order to form a double set of semantics, they are not governed by a strictly codified system, but by a softer and more open type of association, not totally established in advance. This system one guesses is, in the event, the metaphor. We propose to show how such a metaphorical association works by studying the Comares Hall, once again beginning with the same crucial problem of representation.

THE PROBLEMATIC OF REPRESENTATION IN THE COMARES HALL

Until now, scholars have interpreted the Comares Hall as a cosmological representational picture of the seven Islamic heavens. In detail, the wooden ceiling would be seen as a kind of iconography of the heavens, while the theme of the royal kingdom would symbolically take place beneath it, formed by the supporting walls with the alcoves. Two main factors have led to such an interpretation. The first concerns the content of the poetic and Qur'anic epigraphy, interrelated with some striking visual effects which constitute the second factor. Both factors form the objective aesthetic parameters, linked with one other by a relationship of sense which confers meaning on the architecture and implies various types of perceptive phenomena, insofar as the things seen and the things read, or at least memorised, logically produce two kinds of cognitions: visual and textual. This particular aesthetic language has to be deciphered in order, firstly, to demonstrate how the interpretation cited is wrong, and secondly, of course, to propose a new one. For this, we need to state the primary aesthetic parameters in question.

Clearly the epigraphy (the first factor or element of the system) deals with the dual theme of the creation of the universe and the powers that come into play in existence,[10] namely the superior power of God, the perilous power of evil and the temporal power of the sovereign. Thus, at the entrance to the hall and around the arch over the central alcove, the short sura *al-Falaq* (Qur'an 113, Daybreak), is inscribed:

In the name of God, the Merciful, the Compassionate,
Say: I take refuge with the Lord of Daybreak,
from the evil of what he has created,
from the evil of darkness when it gathers,

49

from the evil of those who blow on knots,
from the evil of an envier when he envies.

Then, just beneath the dome, one finds sura *al-Mulk* (Qur'an 67, The Kingdom) in its entirety from which we quote some important verses in respect of the aesthetics of the building:

In the name of God, the Merciful, the Compassionate,
Blessed is He in whose hand is the kingdom, He is powerful over everything,
Who created death and life, that he might try you which of you is fairest in
 works, and He is the Almighty, the All-forgiving,
Who created seven heavens one upon another. Thou seest not in the
 creation of the All-Merciful any imperfection.
Return thy gaze; seest thou any fissure? Then return thy gaze again, and
 again, and thy gaze comes back to thee dazzled, aweary.
And We adorned the lower heaven with lamps, and made them things to
 stone satans; and We prepared for them the chastisement of the blaze.

Inside the central alcove, at eye level, where the sultan himself sat enthroned during audiences, is a poem which, as if lending the power of speech to the part of the building it decorates, says:

You received from me morning and evening salutations of blessing,
 prosperity, happiness and friendship.
This is the light dome and we are its daughters; yet I have distinction and
 glory in my family.
I am the heart amidst other parts of the body, for it is in the heart that
 resides the strength of soul and spirit.
My companions may be the signs of the zodiac in its heaven, but to me
 only and not among them is the sun of nobility,
For my lord, the favourite of God, Yūsuf, has decorated me with the clothes
 of splendour and of glory without vestments,
And he has chosen me as the throne of his rule ; may his eminence be
 helped by the Lord of Light and of the divine Throne and See.

Obviously, the assembly of these inscriptions forms a semantic collection focused on the Islamic cosmological order which is arranged in a strict hierarchy. Not only does sura *al-Mulk* deal with the main religious and ontological questions related to the Creation, that is to say the

relationship between God and His creatures, the Divine Attributes of power, the issue of life and death, the duality of the believers and unbelievers, and so on, but it also provides cosmographical features, i.e. a kind of physical description of the world with its division on two planes: the upper constituted by the seven heavens, perfectly ordered one upon another and forming a sort of isotropic morphology, over the lower plane of the earth (equally divided in seven parts).[11] In other words, in this sura, the Qur'an draws a synthetic textual picture of the world that one can mentally imagine in terms of perceptual qualities and primary physical notions, that is to say an absolute isotropy of the celestial bodies, distributed numerically in seven parts according to a perfect ascending and descending order—a sacred picture that projects a strong impression of wholeness and harmony, and that contains the fundamental metaphysical notion of oneness comprising multiplicity.

Beneath the dome, the poem on the alcove arch acts as a response to the sura, as a human voice replying in poetry to the divine Word. Topographically inscribed down the hall, at eye level, so legible from a standing position, and juxtaposed to the Qur'anic inscription high above, the poetic inscription follows the fundamental law of hierarchic distribution of the heavenly and earthly bodies, stated in the Holy Book in highly minimalist but powerfully rhetorical language. Naturally, this Qur'anic description of the universe gave rise to various complex theories developed in philosophical and scientific sources.[12] From the point of view of the different constitutive ontologies of the universe, an important passage in the Neophytagoric and Neoplatonic *Rasā'il* by the Ikhwān al-Ṣafā' (fourth/tenth century), gives an idea of one of the multiple aspects of the Islamic cosmological vision:

> The works of Nature are the forms of the animals, the various types of plants and the different mineral substances. The spiritual works are the order of the four sub-lunar elements, fire, air, water and earth, in the structure of the celestial spheres and the formal order of the world. The divine works are the forms abstracted from matter and created from nothing by the Creator of everything.[13]

To return to our semantic analysis of the poetic inscription, by invoking

the sun and the signs of the zodiac, and using the word 'daughters' for the metaphorical designation of the alcoves ('This is the light dome and we are its daughters'), the poem situates the area of the building it is praising above the lower plane of the earth. More precisely, it situates it within the sphere closer to the upper heavens, the astral sphere which corresponds to the firmament of the planets. Indeed, in Islamic cosmology in general, the latter precedes the highest and eternal heavens within which stand God's Footstool and Throne, constituting an intermediary world between them and the earth. Continuing with the poem, the royal seat itself appears symbolically located in this intermediary celestial sphere, above the sub-lunar region. This undoubtedly means that the king himself holds a superior rank, closer to the most elevated heavens, than the common people.

These poetic and Qur'anic cosmological semantics make sense in respect of the specific function of the edifice, which is the throne hall where the expression of royal power assumes its full significance. It is here that the sovereign shows himself to be both the foremost of the believers and the supreme example of the faithful before God. Thus, the epigraphy appears invested with a double cognitive purpose. Above all, it acts at the strictly literal level, as a text delivering religious thoughts and derived meanings, both in absolute terms and regarding civilisational contingencies. This means, firstly, that the sacred inscription addresses these thoughts and meanings to the Naṣrid representatives of the *umma* and to contemporary visitors, gathered in the audience room, thereby indicating the power of the Spanish dynasty as the local Islamic authority. Secondly, it means that beyond its immediate audience, at a symbolic level, the inscription addresses everyone in the perspective of posterity, an objective that inevitably all royal works of art aim to fulfil.

This primary cognitive function combines with another function of an aesthetic nature. By virtue of their being incorporated into the material of the building and of their presence, the inscriptions play a full part in the aesthetic phenomenology of the building as veritable centres of activation of its ontological relationship with the world. Obviously the occurrence of the texts within the architecture involves *a fortiori* an interrelation and interactivity between the practical significance of the

place and the abstract significance of the words. Thus, through the specific physico-semantic link that relates them appropriately to their material basis, the inscriptions make the latter resound with the cosmological evocations they carry, and transform it metaphorically into a microcosm reflecting the macrocosm.

Conversely, this powerful process of structuring and determining architectural space by means of textual material, is sustained by impressive and dramatic visual effects, the other element of the aesthetic language in this room. The dazzling all-over decoration acts as a perceptual conditioning which enables the viewer to be projected into this microcosm defined by the epigraphy, through which he perceives the macrocosm's order in visual terms: it does not concern an objective visualisation as such, but an oneiric vision occurring through the prism of artistic wonderment. More precisely, by allowing the spectator to feel with his senses, through a purely aesthetic perception, the order of the architectural microcosm, and beyond, the order of the macrocosm, the decorative configuration prepares him to receive the whole spectrum of spiritual, ontological, ethical and political cognitions that flow from it. This visual conditioning operates as follows:

One sees an ornamental continuum, organised in strictly geometrical panels and planes, that successively changes material in a sharply upward-sweeping movement, moderated by strong horizontal lines that correspond to the ranks of different juxtaposed parietal features. This continuum leads the eyes progressively from the bottom to the top, to the astonishing vision of the masterpiece—the wooden ceiling which crowns the richly decorated room shaping a realm of wonders beyond the rational world. We must remember that all of the ornamentation, including the wooden ceiling itself, was originally painted in bright polychrome colour.

The open traceries also contribute to this sophisticated aesthetic of progressive amazement, with their skilful means of filtering light to the hall, again via a hierarchic and vertically oriented network. Down below, as fits the human scale, the wide-open alcoves allow generous amounts of intense light to penetrate, maintaining communication with the outside world through a panoramic view onto the city. Above these big

windows, a large area of the walls remains blind, creating an interval before the upper level of the square is reached, as though passing into a space disconnected from the lower and from the outside world. Upwards, a series of smaller openings filter the light through geometrical lattice-work, a soft and almost unreal light which has no link with the direct and physical light down below, an almost magical light, which subtly reveals the dome, the completion of this visually uplifting phenomenon.

From this analysis, it appears that the architectural space is divided into two main aesthetic planes in opposition: the lower, rational plane of the series of alcoves, at the human level, corresponding to the imme-diate corporeal world, and the upper supra-rational plane of the area that spreads out above, corresponding to the conceptual, imaginative and projective world. Taken together the two planes form a visual itiner-ary that the gaze, guided by the formal disposition of the elements, cannot help but follow.

In other respects also, in the framework of this architectural micro-cosm, the aesthetic power of the cosmogonic expression concealed by the geometrical design *per se*, reaches a maximum degree of effective-ness. In particular its 'idealising power', due to its 'level of absolute ideal objectivity',[14] allows geometry to embody, at a second level of signifi-cance, the metaphysical concept of celestial immensity. There is no doubt that while contemplating the dome with its radiating star patterns, im-ages of constellations come to mind, like pictures of the firmament. There is no doubt either that the geometrical ornament, essentially, refers also to the sense of order that reflects, in the physical creation, the perfect harmony of the creation as a founding structural principle.

To summarise, the semantics of the design, the various architectonic features and the epigraphy, shape a highly rhetorical conjunction of aesthetic elements that cause a flow of cognitions through the dual path of both mind and senses.

This investigation demonstrates, without great difficulty, the perfect and meaningful binding between the scriptures and the perceptual con-ceptualisation of the room, that is to say between both of the factors that caused scholars to interpret the Comares Hall as an imaging representation of the cosmology of the Qur'an. Indeed all the visual

signs assembled in the architectural work function as a kind of meta-physical itinerary in matter. They create a progressive elevation from bottom to top, through a succession of different spatial entities formed by the diverse planes of the square, until they reach the place of ulti-mate splendour and marvel, the wooden dome. For Western observers, accustomed to thinking in terms of artistic expression as governed by a system of literal representation, i.e. by a relationship which 'mirrors' ideas and forms, such an artistic combination could not be anything other than figurative. One can find evidence of this point of view, for example, in Oleg Grabar's book, *The Alhambra*:

> It is rather strange that only Nykl and later Bargebuhr[15] realised that it is precisely the seven heavens of the Qur'anic quotation that are represented in the decoration of the ceiling with its six rows of stars and its central small cupola.

Some pages on, Grabar mentions 'two-dimensional and schematic symbols of the hall'.[16] Some years after Grabar's work, Dario Cabanelas, a Spanish scholar who wrote a monograph on the Comares dome, confirmed this hypothesis, arguing in addition that each corner of the ceiling, made of four joined wooden pieces, represents a tree of life.[17] This hidden iconographic theme would symbolise the Islamic Paradise that the Qur'an describes in terms full of imagery: at the demarcation between the realm of the planets and the upper heavens stands the gate-way of Paradise where grows the 'Lotus-tree of the Boundary', and from its roots four rivers spring.[18] This quite weird (and to us incorrect) in-terpretation of an observable image created by the abstract configuration of the ceiling, results from a misunderstanding of the aesthetic concept of representation itself and, consequently, of its practical implications in art. At this point in our discussion, we need a theoretical support.

In theory as concerns the general rules of art, when one asserts that A literally represents B, one strictly means that A is a fictional substitute for B or an equivalent for it. This assertion may be valid only if a con-crete system of demonstrable aesthetic signs confers on A such a power of substitution or equivalence with B. However, the aesthetic concept of representation is distinct from the concept of artistic identification,

insofar as, to borrow Arthur Danto's elucidating words, 'the fact that A is identical to B is compatible with the lack of literal identity'.[19] So do we find in the Comares dome an objective system of signs susceptible to making us think that it actually represents the Islamic heavens or is a formal substitute for them, literally a heavenly iconography? Is the semantic correspondence that we have shown between the content of the inscriptions and the architectural semiotics sufficient in itself to sustain such an interpretation? The answer is no, for several reasons:

Firstly, it is quite difficult to interpret the ceiling drawings as legible images because a similar ornamental vocabulary appears everywhere in the Alhambra, on walls, doors, floors, etc., and more broadly, on many Islamic artistic devices that do not have the particular purpose of representing cosmic themes.

Secondly, the structural construction as well as its aesthetic properties deny any particular numerical coincidence with the seven Qur'anic heavens. On the one hand, the seven rows mentioned by the scholars concern in an undifferentiated manner patterns which are grammatically diversified: small stars organised in concentric circles, big stars like flowers and half-stars. Therefore, if one counts the designs by type, one does not obtain this number. The small central cupola itself works as a major but isolated pattern, a conditioning pole of the general concentric disposition and movement. Nor can it be considered as a feature additional to the rows spreading all around. Consequently, there exists no evidence to attribute the geometrical constitution of the dome to the number seven in particular rather than to any other type of mathematical axiom that could be suggested according to the different patterns. The structural principle that subtends the design is, in fact, the principle of the series, expounded in a Socratic writing style (such as an inner dialogue) in Ludwig Wittgenstein's *Philosophical Investigations*:

> 228 — "We see a series in just one way!"—All right, but what is that way? Clearly we see it algebraically, and as a segment of an expansion…

> 229 — "I believe that I perceive something drawn very fine in a segment of series, a characteristic design, which only needs the addition of 'and so on', in order to reach infinity."[20]

So each type of star pattern is conceived as a series that indeed conceals the power of being indefinitely extensible. Having no specific link with the sacred numerology in the Qur'an, the conclusion is that no observable parameter permits one to read in the ceiling's geometry purposive symbolic or representational meanings related to it.

In other respects, to restrain the starry vocabulary to seven groups of patterns, would imply necessarily that the aesthetic space of the dome is objectively—i.e. as it appears to the sight—an achieved space, like the geometrical image of the seven heavens depicted in the sura *al-Mūlk*. On the contrary, the general organisation of the ceiling shows the opposite aesthetic vocation. It immediately produces the optical effect of boundless space, given that not all the geometrical patterns convey the same idea of spatiality and induce the same visualisation of it. Wittgenstein, again, notices that:

> Certain drawings are always seen as flat figures, and others sometimes, or always, three-dimensionally. Here one would now like to say: the visual impression of what is seen three-dimensionally is three-dimensional; with the schematic cube, for instance, it is a cube (for the description of the impression is the description of a cube).
>
> And then, it seems queer that with some drawings our impression should be a flat thing, and with some a three-dimensional thing. One asks oneself. Where is this going to end?[21]

The character of limitlessness of the roof area is due to three of its perceptual qualities which derive from and deliberately play with the intrinsic property of infinitisation of geometry as a material ontology.[22] The first quality concerns the algebraic law of the series cited above, according to which different starry features expand around the central cupola, in an homogeneous and virtually endless concentric distribution. The second quality resides in the organising principle of alternation of these features that, like the serial principle of which it is the corollary, equally possesses the specific ability of endlessly expanding. And lastly, the third quality lies in the highly determining treatment of the ceiling edges, a problem that needs, once again, a short theoretical explanation.

As a general rule, any type of aesthetic morphology is defined by the

nature and content of its matter and the mode of spreading of this matter within space, namely the position of its limits, its horizon. Thus, the affirmation or, on the contrary, the negation of the edges of this morphology constitutes a determining element for its ontological status, relative to the aesthetic dialectics between finitude and infinitude involved in the phenomenology of created visual spaces, above all in the phenomenology of pure geometrical space. What Danto explains about paintings is equally valid for any visual form:

> The edges of pictures have always played an important role in painting, and it is certainly exact to say that they are those which generate the composition that fills the space they delimit, because it is in relation with the edges that the focal points and the points of view are compositionally conceived.[23]

Returning to the case of the Comares dome, by virtue of aesthetic relevance of the limits, the half-stars at the margins of the supporting square strengthen the virtual continuity/infinity of the design beyond it, in an endless expansion which confers on the artefact the aesthetic character of a space in dilation, of an open field. Such a property makes the ceiling morphology oppose the enclosed shape of the Qur'anic heavenly bodies, due to their strict numerical limitation. The area where the walls and roof meet, namely between both edges of the two parts forming the hall structure, draws a sharp line outlined by an impressive *muqarnas* cornice. No transitional elements mediate the meeting between the squared and circular morphologies; an observable fact meaning that aesthetically they do not meet each other, but are outdistanced occurrences. The concrete result of this disposition is a radical change that operates between two absolute distinct and parallel spaces: one condensed and circumscribed by four walls, firmly limited in their upper part by the cornice; the other spreading infinitely beyond, like a fragment of sky seen from an open air patio.

In concise terms, the dome configuration offers an exact example of what Michael Fried eloquently called 'a deductive structure', speaking about the works of Frank Stella, the American abstract artist, especially the paintings that present concentric stripes. (Plate VIII) They are

deductive structures in the sense that they (the paintings as well as the Naṣrid device) 'have been, so as to speak, generated *in toto* by the specific forms of their outer edges'.[24]

Naturally, such a conception for the ceiling cannot have come about by chance, but must have resulted from a deliberate aesthetic intention—the desire to generate the visual sensation of endless space. Seen in the phenomenological terms of anthropo-cosmology,[25] this 'endless' space could be equivalent to the infinite and unfathomable celestial realm. Or, to mention the explicit expression used by another philosopher of art, Michael Baxandall, the boundless space of the Comares dome is a 'pattern of intention',[26] of expressing by resonance the dual metaphysical concept of immensity and infinity. Here, it seems relevant to remember that this dual concept was extensively discussed by the medieval thinkers, not only in Islam but in all three monotheisms.[27] In a broader perspective, the dome forms the pattern of the *absolute space*, to be included under the universal cosmic theorem of the imagination of the celestial world that can be defined as: all that has the round morphology of a canopy vault refers to the vast firmament.

This way of considering this geometrical configuration shows that Cabanelas' hypothesis of an iconography of paradisal trees in the corners of the roofing is totally meaningless. The presence of legible figurative images in an abstract unlimited aesthetic space has no logic. The junction between the wooden parts of the pyramidal canopy corresponds apparently to a technical constraint that the aesthetic disposition hides perfectly by integrating it within the radiant movement of the dome. In the same way, it does not provoke breaks within the aesthetic rotation of the starry patterns. This last remark on Cabanelas' misinterpretation leads us to our own approach to the Naṣrid building that considers it as a visual metaphor.

THE COMARES DOME AS VISUAL METAPHOR

The aesthetic articulation between the visual and textual materials of the Comares Hall proceeds from metaphorisation which thereby provides it with the artistic identity of visual metaphor. This claim can be demonstrated by the phenomenological analysis of the basic experience the building induces in every viewer aware of all of its objective parameters; that is to say, an experience which constitutes an event occurring again and again, *here* and *now*, since the monument is still standing and since there are still people visiting it. There is no need at all to take into account any specific cultural or historical determinations. It is a question of referring back to the phenomenological primordiality, to that of sense, of ground, of the *de jure*, after the reduction of all factuality. In other words, the assertion can be demonstrated by the analysis of the functioning of the hall as an aesthetic phenomenal field, insofar as every existing work of art constitutes, in essence, an appeal to individual consciousness—in this case consciousness through vision. What actually happens while the spectator or the visitor is 'in the existence itself'[28] of the work of art? That is what we will attempt to grasp in order to restore the genuine meaning of the building conceived during the Naṣrid epoch.

While the visitor stands (or sits) inside the reception room, admiring the amazing decoration through which he perceives a visual echo of the textual imagery of the inscriptions and receives their cosmic resonance and meaning, he feels he is within a cosmogony. Looking at the wooden vault in particular, there occurs a strong sensation of vision-like constellations, or a type of celestial image. Nevertheless, as we discussed previously, nothing indicates that the star patterns can be properly identified as direct symbols or as a purely astral theme in a configuration conceived to represent a defined iconography. So, as there exists no manifest visual symbolisation nor visible images, how does such a process of vision-like heavenly pictures happen?

We can immediately suggest that even if these patterns are definitely not materially determined pictures of constellations, logically they are geometrical shapes presenting analogies with certain common imagery inspired by constellations or the firmament. Starting from this deduction,

it is easier to go deeper into the problem. Actually, the visual mechanism in question originates from a conjunction of two distinct phenomena: firstly, a phenomenon of *imaging suggestion* emanating from the architecture, precisely from the general formal configuration which produces analogies and references to the cosmic themes developed by the inscriptions; and secondly, a phenomenon of *imaging associations* occurring during the visual perception of this configuration, that is to say imaging associations occurring in the viewer's mind.

The first phenomenon, imaging suggestion, is generated by the body of legible signs that we have described and that shape the morphology of the hall, namely the geometrical design, the traceries, the light and so on. These signs, again, do not define concrete images or symbols, but instead constitute a receptacle *in potentia* of the significations and figurative identities to which they refer by this very particular double path of analogy and resonance. This means that they do not intrinsically possess these meanings which are only possible references to variously connotated cosmic entities, the Islamic heavens, the celestial vault, the superior divine world, etc. In simpler terms, aesthetically and ontologically, these signs are not 'something' and do not designate something; they *could be like*, they *evoke* or they *look like* something, by resonance or by analogy and some shared features, whether concerning perceptual analogies, conceptual analogies or analogies of value.

Thus, the vault does not represent the starry sky, nor the divine sphere, nor the seven heavens. It resembles in some perceptual aspects the starry sky, and/or it evokes (an act falling under the concept of resonance) the heavens through, for example, the value of physical harmony and perfection, or through the concept of absolute space it expresses in formal terms. In the same way, its round shape, strengthened and animated by the concentric motion of the patterns, very probably conceals the property of evoking the ideal spherical morphology of the astral bodies that many Muslim medieval thinkers, such as the Ikhwān al-Ṣafā', indeed considered as the most perfect:

> That is why He [the Creator] shaped the celestial spheres with the spherical form, because it is the most perfect of shapes (*afḍal al-ashkāl*), and it is

the broader and the farthest one from any defect and the speedier one; it has its centre in the central point, all its parts are equivalent, only one surface surrounds it, nothing else than one surface can touch it on one point alone; [it has] characters that are exclusively its own, and in addition, its movement is circular which is the most perfect of movements.[29]

Being a receptacle *in potentia* of all these cosmic concepts and pictures, thanks to the aesthetic language of suggestion, the Comares dome can become, by extension, a receptacle *in act*, thanks precisely to the aesthetic language of metaphor. Concretely, it means that, through the transfer process which specifies the metaphor and makes it distinct from the suggestion, the Qur'anic and poetic images find the possibility of a bodily transposition, of acquiring virtually corporeal forms or a kind of visibility. As a matter of fact, the metaphor corresponds to the ultimate development of the suggestion on which it depends entirely. The latter opens the path to the former which transforms the passive reference of visual signs to cosmic meanings, by analogy and resonance, into an active reference, by transfer and identification of the one with the other. We could assert that the suggestion and the production of the metaphor itself are respectively the passive and the active steps of the same universal phenomenon of metaphorisation.

But for a total accomplishment of this metaphorisation, i.e. to render effective the mutation of the language of evocation or suggestion into true metaphor, a process of activation is obviously necessary. Without it, as such, the dome remains aesthetically a body of *potential* metaphors, a kind of undefined, polysemic image in the Russellian sense. Speaking about the generic notion of image, Bertrand Russell states an aesthetic property that particularly fits our Naṣrid device:

> The meaning of an image is constituted by a combination of likeness and associations. It is not a sharp or definite conception, and in many cases it will be impossible to decide with any certainty what an image means.[30]

This procedure regards the second process mentioned above, the imaging associations, that interfere at this crucial point of the phenomenological function of the hall. It is these imaging associations that properly lead to the formation or the definition of the metaphor, by an

effective identification of the epigraphic sense with the artistic matter. As a mental process, they belong to the subjective field of the imagination which is stimulated on purpose by visual suggestion. In this way, they constitute the experimental part of the metaphorisation which occurs during the perceptive activity, namely during the spectator's experience of the building, as follows:

The spectrum of potential metaphors it conveys and the kind of indefiniteness that characterises its artistic identity shapes the architectural configuration into an open, polysemic field favourable to imaginative activity. More accurately, this configuration appears as a scene inviting the visual projection of the cosmovision depicted in the epigraphy, by means of the cogitative faculty as the Andalusian philosopher, Ibn Rushd, defines it, commenting upon Aristotle's *De anima*:

> In fact, as we explained in the book *The Sense and the Felt*, when it joins with the informative and the rememorative, the cogitative faculty is naturally suited, starting from the images of things, to render present to the agreement and the conception a thing that had never been felt, in the disposition itself which would be its own if it was felt; and it is then that the intellect judges these images with a universal judgment.
>
> What we intend to mean by 'cogitation' is nothing other but this, namely that the cogitative faculty poses the thing missing for the sense as a felt thing. And therefore human perceptions divide themselves into two: those of which the principle is the sense and those of which the principle is the cogitation.[31]

And indeed, the perceptive response to the aesthetic invitation of the Comares Hall is positively an act of projection of which the principle is cogitation, subtended by imaging associations (all these processes being typical of what one universally calls 'imaginative activity'). While contemplating (or using) the architectural configuration, the viewer's sight perceives nothing defined *a priori*, but in return receives multiple visual suggestive signs. These signs are, unlike those forming a direct representation, a nondirective appeal or, rather, a pluri-directional appeal, so that instead of following determined and univocal rules of understanding the building, one interprets it *a fortiori*, i.e. one interprets the interplay

of the formal and textual cognitions received from it, in accordance with one's own imaginative and cognitive disposition. This occurs in such a fashion that one necessarily adapts the epigraphic significations to the formal visual aid, and consequently projects on to the architectural scene one's own understanding of the proposed cosmo-vision.

It is within the subjective space of the aesthetic experience that the things seen (the architectural forms) and the things known (the epigraphic content) truly articulate themselves, in fact giving birth to diversified semantic connections. Among these connections, imaging associations take place that govern the determination of metaphors, namely, the mutation of a certain potentiality of virtual images into defined metaphors. Under the dual effect of visual suggestion and scriptural imagery, all those faculties related to the imaginative (the cogitative, the informative, the recollective and so on) are excited and build various combinations, associations and correspondences, through which the material field fills with the epigraphic sense and identifies its perceptible forms with iconological elements. For, according to Ibn Rushd:

> These three faculties are in the human being to render present to him the form of the imagined thing when the sensation is absent. So it was told there that, by a co-operation between themselves, these three faculties can represent the individual thing according to what it is in its being, although we do not feel it ... These faculties are indeed like the things that prepare the matter of art to receive the action of art.[32]

The Spanish Muslim philosopher goes on to explain that the viewer does not observe cosmic images or entities through his eyes, but 'is in fact cogitating as if he were seeing (says Aristotle). That is to say, the principle of his cogitation about things indeed consists in rendering present all the different kinds of images of the imagined possibilities concerning the thing on which he is cogitating, as if he were seeing what he is cogitating on.'[33] This phenomenon of identification, that corresponds to the achievement of the visual metaphor in Naṣrid architecture, relies on the so-called 'as if' principle, widely discussed by Wittgenstein:

Here is a game played by children: they say that a chest, for example, is a house; and thereupon it is interpreted as a house in every detail. A piece of fancy is worked into it. And does the child now see the chest as a house? He quite forgets that it is a chest; for him it actually is a house. (There are definite tokens of this.) Then would it not also be correct to say he sees it as a house?[34]

This associative principle constitutes the primal mental mechanism of metaphorisation in any realm—language, poetics or visual arts.[35] Additionally, the Austrian philosopher explores its application in the field of geometry which is the one that particularly interests us:

Take as an example the aspects of a triangle. This triangle can be seen as a triangular hole, as a solid, as a geometrical drawing; as standing on its base, as hanging from its apex; as a mountain, as a wedge, as an arrow or pointer, as an overturned object which is meant to stand on the shorter side of the right angle, as a half parallelogram, and as various other things.[36]

In the phenomenology of the audience room, this 'as-if' principle activates what we can term, after Bachelard, 'the intimate imaginary space of the metaphor' where individuality projects itself:

The space grasped by the imagination cannot remain the indifferent space given to the measure and reflection of the geometer. It is lived. And it is lived, not in its positivity, but with all the partialities of the imagination.[37]

Altogether, these complex phenomena are those that generate the specific sensation of vision-like celestial pictures in the Naṣrid ceiling. And to correctly answer the question which caused us to explore these phenomena, we will state that this picture results from the particular procedure of the imaginative superimposition (the mental projection or the cogitative transfiguration) of the scriptural cosmography on the perceptual scene of the architecture, transfiguring the latter into a corporeal manifestation of the former. Thus, it is a picture that is present *in act* as if it were *present* in the sensation. The type of artistic work that derives from such a way of rendering visualisable non-visible things, falls under the phenomenological concept of 'the imaging metaphor': a non-

representational proposition invested with a figurative power[38] that produces materialised inner, mental, images, such as the celestial picture in question. Wittgenstein, again, concisely describes this process of inner visualisation:

> What I really see must surely be what is produced in me by the influence of the object. —Then what is produced in me is a sort of copy, something that in its turn can be looked at, can be before one; almost something like a materialisation.[39]

Nevertheless, as we mentioned above, this response to the aesthetic stimulation through the metaphor of the ceiling is only one among other perceptive possibilities. Since the aesthetic system of the Comares Hall allows for the subjective contribution of the viewer, it opens the field to various experiences, more precisely to three types of experience, including the one we have just described. Firstly, the later perceptive experience of mental visualisation, which fully partakes of the metaphorical game, originates from a projective and cogitative attitude that establishes a literal representational link between the forms and the inscriptions of the building. This especially concerns those scholars who erroneously considered their own projective view as an objective analytical understanding of the architecture, because of their representational habits and practices.

Secondly, there is the case of the spectator who may appreciate the formal arrangement of the hall only as a kind of marvellous and appropriate but purely material framework, for a purely mystical or spiritual experience. The cosmological scenography composed by the architecture offers, then, only a pretext for projecting the mind into an abstract meditation. As opposed to the previous attitude, this does not properly lead to a union of textual and visual matters, but rather maintains ontologically disconnected the corporeal and spiritual worlds.

Thirdly, the last type of perception consists in positively maintaining the aesthetic relationship between forms and texts, but without recognising any specific iconography behind the geometrical design, i.e. without literally identifying a particular cosmic topic to a particular architectural feature. Such an understanding of the building follows the conceptual principle clearly defined by the contemporary French painter

Yves Klein as 'an abstract idea represented in an abstract manner'.[40] In this third case, the dome appears as a conceptual support to the metaphysical concept of the superior heavenly world that derives from the inscriptions. The perceptual properties of abstraction proper to geometrical drawings fully sustain this vision of the work of art. To borrow, once again, Wittgenstein's penetrating words, the spectator is allowed to say, in any of the three cases:

> This is what I treat it [this image] as; this is my attitude to the figure. This is one meaning in calling it a case of seeing.[41]

If we have to summarise the aesthetic of the Comares Hall, we should say that it forms a projective aesthetic space inducing projective behaviour, by means of the system of visual metaphor. This system presents the important advantage of allowing subjectivity to get a large part in the creative process, and of stimulating the activity called in Arabic *takhyīl*, that can be translated as 'fantasy' or 'imaginary suggestion' or 'imaginary representation'.[42] Classical Arabic thought deals extensively with this concept and, more generally, emphasises the creative faculties of the human being through imagination, as we saw for example through Ibn Rushd's debate on the cogitative faculty. The principle of *takhyīl* is not so fundamentally involved in the phenomenology of traditional representational creations, insofar as any observable image defines the rules of its visual cognitions prior to the act of perception. While these creations absolutely require the understanding of rules, visual metaphor gives free reign to interpretation.

In addition, the metaphorical language resolves in the practice of art the difficult question of how to represent the unrepresentable, and by extension, how to represent without representation. The specific type of the imaging metaphor supplies a mode of virtual representation, a means of visualising the invisible that the Comares Hall exploits with a high degree of rhetoric. There is here certainly a manner of seeing the Qur'anic heavens, the divine sphere and other related unrepresentable Islamic entities, or essentially—we may say, for everyone—the unrepresentable immensity of which a medieval Latin scholar said, 'The mind cannot give either form or figure to immensity. If it did, immensity

would be thought of as finite, and if this happened, immensity would not be thought of as immensity.'[43]

4

Abstraction, Kinetics and Metaphor: the 'Geometries' of the Alhambra

Geometrical thought penetrates myth; reciprocally, the discourse of myth pervades geometry.

Michel Serres[1]

This chapter, dedicated to geometry in Islamic art, once again refers to the Alhambra as an example because of the extensive and skilful use of geometric decoration in its design. This study of the aesthetics of the Naṣrid building will allow us to develop the discussion begun in the previous chapter. There are numerous works on Islamic geometry as a major artistic theme in this civilisation in general, and in the Alhambra in particular, to take into account. Nevertheless, we will limit ourselves to mentioning two important books that have recently contributed significantly to this subject: *The Topkapi Scroll: Geometry and Ornament in Islamic Architecture*, by Gülru Necipoğlu,[2] and *The Alhambra, From the Ninth Century to Yūsuf I*, by Antonio Fernandez Puertas.[3]

Concerning geometry as both practice and theory applied to art, Necipoğlu's book is particularly enlightening because of her meticulous reconstruction of its history and technical evolution from the Middle Ages to the modern period, starting with the study of modular drawings

from the Timurid period, in the so-called 'Topkapi scroll'. In particular, Necipoğlu explains the rise of artistic geometry in close and logical correlation with the overall intellectual framework of medieval Islam, focusing primarily upon the Abbasid court in Baghdad, which was marked by scientific, philosophical and theological turmoil with reason and faith engaged in a fruitful dialectical battle. She also approaches Islamic geometry from the innovative angle of semiotics. Thanks to this method, she brings to light an important aesthetic phenomenon: namely, that the various dynasties and governments from the period preceding the formation of the great modern empires of the Ottomans, the Safavids and the Mughals, used geometry as a visual mode of political representation, composing distinctive configurations in architecture that everybody could easily recognise and immediately attribute to their prestigious owners. Therefore, for instance, late medieval buildings from Muslim Spain, the Maghreb or Iran, cannot be mistaken for each other, as each architectural type is characterised by its own geometry expressing in formal terms its familial, ethnic and religious or politico-historical affiliation. In short, these geometrical programmes in architecture and decoration provided a badge for the sovereignty of Muslim princes that functioned as an informative visual code, a princely label.

However, although in many respects we continue to increase our knowledge of Islamic geometrical art, its history and semiotics, and all that concerns its structural characters, its mathematical laws and constitutive variants,[4] and its global philosophical motivations, substantial problems still remain, particularly within the realm of visual aesthetics. Thus, the aesthetic phenomenology of geometrical ornament, its purpose as well as its logic in terms of the language of material expression, has not stimulated much in-depth reflection. The purpose of this chapter, then, is to tackle these issues, by analysing the design in this 'conservatory' of Islamic geometrical art that the Alhambra constitutes. Such an undertaking urgently needs re-stating in epistemological terms.[5]

TOWARDS A NEW APPROACH TO ISLAMIC GEOMETRICAL ART

From ancient Greece to the Renaissance, and revived since then from the time of Cézanne, in Western art the aesthetic concept of geometry has been considered fundamental to the creative process and indeed to the visual apprehension of the world itself, prompted by the consciousness of its mathematical roots, that is to say, the 'fundamental conditions of the constitution of forms in space'.[6] From this comes the extraordinary flowering of artistic trends based on the geometrical form, from pictorial and sculptural Cubism in Europe to American Abstract Expressionism, to Russian Suprematism and other aesthetic explorations of the 'idealities of mathematics'.[7] Clearly, it is not that the geometrical theme was more developed in the contemporary Western world than in Islam or elsewhere—far from it. But the specific approach to art that the predominantly positivist outlook of the twentieth century generated led to a new way of considering the artistic process in general. During this period, a specialised knowledge and application of geometric principles in art offered a means of transcending the world of images in order to develop a more conceptual expression of reality. These ideas gradually took precedence, as artists produced accounts of their working methods, and critics, philosophers and art theorists wrote theoretical texts about these new geometrical visions of the world.

Such material provides an invaluable tool for deriving knowledge of the concepts and aesthetic phenomena involved in geometrical design, its multiple modes of artistic conceptualisation, its potential for expressivity and the processes of abstraction it allows in the realm of the visible. These concepts and phenomena, which were always tangibly present but never before spelled out objectively in the context of an aesthetic reflection on traditional arts like those of Africa and the Muslim world, are henceforth formally designated, rendered intelligible, and demonstrated visually by application in artistic works. For instance, contemporary art and art criticism demonstrate the most subtle and complex mechanisms of abstraction in sensible forms, especially through the dispute about figuration.[8] We can, therefore, with respect to our aesthetic enquiry, benefit equally from this Western knowledge of artistic geometry, notably

by establishing parallels and comparisons with contemporary artistic works.

Far from seeming anachronistic, these works will help to answer an unresolved dual question that Oleg Grabar highlights in his review of *The Alhambra* by Fernandez Puertas. This question concerns the nature of the activities and experiences for which the arrangement of the Naṣrid palace was conceived, and what its forms mean, given that it could not be merely 'a museum of geometrical shapes'.[9] Secondly, Grabar wonders what the contemporary user of the building really saw in these configurations of geometrical ornament? He suggests that it was probably not 'the brilliant reconstruction of a meaningless past of geometric shapes', but rather 'some response to his own aesthetic needs, which, like any great work of art, the Alhambra anticipates'.[10] Our analysis aims to offer some explanations or open the way for answers to these questions.

THE GEOMETRICAL SYSTEM OF THE ALHAMBRA: A CONJUNCTION OF GEOMETRIES

Anyone visiting the Naṣrid site at first glance undoubtedly finds himself overwhelmed by the visual impression of extreme geometrical sophistication in the architecture as a whole. Such an impression has precise causes which have not been truly understood and still continue to challenge the observer. To grasp this phenomenon better, we should first of all present a brief review of the known parameters.

Numerous structural studies of the geometrical decoration of the Alhambra reveal that a broad spectrum of mathematical systems governs the linear design. But the remarkable variation in the ornamental grammar should not hide the important fact that, at the level of the construction itself, the constitutive geometry is relatively simple. Indeed, the undeniable perceptual complexity of the decoration and the architectural layout, produces a contrast with the quite elementary character of the monument's structure which does not depend on an overly complicated system of mathematical axioms. This structure consists of combinations of architectural bodies, formed by square or rectangular modules of variable scale around which courtyards and rooms are

arranged. Although the elements that cover these architectural units—wooden roofs, so-called *artesonados*, domes and *muqarnas* vaults[11]—generate the optical effect of very skilful geometry, they did not, from the point of view of the technique of building, require knowledge of a particularly elaborate order. (Plate IX) In fact, separately conceived in light materials, such as wood and plaster, they rest upon the supporting structure. They are not articulated organically with the foundations and, consequently, they do not raise the practical considerations linked to the usual problems of weight-ratio and transition between vertical and horizontal, square and circular plans. A simple comparison of the Naṣrid features with the more elaborate constructions from Saljuq Iran of the fifth/eleventh and sixth/twelfth centuries, gives an idea of this aspect of the Alhambra. Unlike the latter, the structure of the Iranian buildings consist of various parts ingeniously integrated, each within the others, into a whole body which, thanks to the most refined constitutive geometry, displays complex numerical ratios.[12] The double dome of the Great Mosque in Isfahan (Plate X) and the mausoleum of the great Sultan Sanjar magnificently illustrate this Saljuq geometrical practice in three dimensions.

This sense of the Alhambra's highly elaborated mathematical configuration thus comes not from its anatomy, i.e. from the primary constitutive level of its architecture, but from its decorative dressing or 'skin', composed by the sum of the elements that transform its architectural morphological schemes into diversified geometrical spaces and surfaces. That is to say, the applied ornamentation and architectonic layout: the stucco and ceramic elements, the reticulation, colonnades, windows and arches, and the crowning features—domes, hanging vaults and roofs which are not, as we said, intrinsically linked with the walls. In other words, the sophistication of the Naṣrid palace works at this second level of modelling by the geometry which shapes the edifice's basic morphology. Moreover, the strictly geometrical patterns are reinforced by the rich decorative outlines of purely ornamental designs which include stylised vegetation, flowers, calligraphic elements and arabesques that line the traceries in some of the architectonic areas, especially those inlaid with stucco. (Plate XI)

Finally, if we rigorously uphold the scientific nature of geometry as a building practice, we could consider this complexity through variation and decoration as 'apparent' or 'illusionist', and assume that this is a result more of optical effects than of a three-dimensional material reality. Therefore, one can say, the geometrical intricacy of the Naṣrid palace appears more aesthetic than structural in nature, insofar as it functions not so much as a building tool but rather as a mode of expression.

Fundamentally, the geometrical science of the Alhambra comes from a highly sophisticated aesthetic conceptualisation. The palatine complex does not simply constitute a geometrical object or the material projection of an exercise of intelligence drawn into the shape of an architectural construction through complicated axioms and tabulations. If this were so, geometry would have supplied both the means and the end of the work of art, according to a single and univocal aesthetic principle. But on the contrary, the geometry in the Alhambra fulfils a plural function insofar as it transforms spaces, volumes and planes into different visual creations concealing different significations by means of a great diversity of aesthetic systems and through the elaborate use of the principle of variation. This means that, instead of a unified geometry, there is a conjunction of several geometries in the Alhambra, or several geometrical propositions differing in content. More explicitly, geometry constitutes the language through which the Naṣrid architecture formulates various propositions in the sense stated by Ludwig Wittgenstein in his *Tractatus logico-philosophicus*, No. 3.13.

> To the proposition belongs everything which belongs to the projection: but not what is projected.
>
> Therefore, the possibility of what is projected but not this itself.
>
> In the proposition, therefore, its sense is not yet contained, but the possibility of expressing it.
>
> (The 'content of the proposition' means the content of the significant proposition.)
>
> In the proposition the form of its sense is contained, but not its content.[13]

On the level of aesthetics, we can group the geometries of the Alhambra into three generic categories, supposing three distinct principles that subtend the visual forms of the building: 'imaging geometry', 'kinetic geometry' and 'conceptual geometry'. These categories follow specific perceptual rules and a particular aesthetic logic that differentiate them, despite the common morphological point linking them which is, of course, their mathematical constitution; an elementary principle that medieval Muslim thinkers developed in their thought, as in the case of the Ikhwān al-Ṣafā' who wrote in their *Rasā'il*:

> Geometry occurs in all the arts (*ṣanā'ī*); every craftsman (*ṣāni'*), if he carries out measures in his art prior to proceeding to practice (*'amal*), it concerns a type of theoretical geometry (*'aqlīyya*), namely the knowledge of dimensions and their content ... Applied geometry consists of the knowledge of measures and its sense, and binding them to each other, being comprehended by sight (*baṣar*) and perceived (*yudrak*) by touch. Theoretical geometry is the reverse, namely, knowledge and pure understanding.[14]

The geometrical constitution resulting from the pure mathematics of spatio-temporal shapes in general forms the primary character of the generic concept of geometry and confers on geometrical arts the particular perceptual property of abstraction, as opposed to the property of figuration. Following the common acceptance of both aesthetic notions, in art abstraction basically consists of an elimination process of references to the matter towards thought, ideality and ideas, whereas figuration, on the contrary, consists of a combination of references to matter in order to represent recognisable existing things and beings. Thus, although the three categories of geometry mentioned above share this perceptual property of abstraction as a founding morphological character, each one possesses its own properties that permit the elaboration of particular propositions stimulating particular aesthetic experiences. Despite the apparent homogeneity of its visual display, it is precisely this diversification that provokes the sensation of changing aesthetic spatialities while visiting the site—a more or less acute sensation according to the cultural determinations of the visitor. The analysis of this process

of diversification needs to define the three generic types of geometrical proposition as to their main qualities and properties, and to expound their phenomenology.

In the Alhambra the three generic types correspond to three distinct languages, but they also share some characteristics and abilities or sometimes combine with each other to form a 'mixed type of geometry'.[15] In addition, certain areas which do not possess any properties of the other three but are merely padding elements, compose a whole 'purely decorative geometry', which should perhaps be considered a fourth category. (Plate XII) These elements, mostly stucco, emphasise surface texture by means of refined work that combines flat-laid and relief sculptures, drawing networks of stylised vegetation, flowers and calligraphic patterns into what are usually known as 'arabesques'.[16] (Plate XIII) In this case, the elementary geometry limits itself to a basic axis of symmetrical composition guaranteeing balance to the vocabulary of profusely intricate decoration. This provides the various combinations of geometrical propositions with a general cohesiveness, while strengthening their visual attractiveness by bringing a sensual beauty to the forms. But this type of geometry, reduced to a latticework of elementary lines, carries no value of sense as such and, therefore, does not constitute a true semantic field comparable to the other geometrical propositions.

IMAGING GEOMETRY

To continue with the topic we discussed in the previous chapter, let us examine the geometrical conceptualisation of the Comares Hall that actually incorporates at least two of the three systems mentioned above, the conceptual and the imaging geometries. We have already touched upon the overall working of the latter on this reception hall, but there is a need to develop this study further.

As we observed, the wooden dome virtually emanates the kind of celestial image which we called an 'imaging metaphor', created by geometrical patterns of rotating stars. These forms supply the necessary support or, to borrow a term from linguistics, the 'vehicle' of the visual metaphor. We have shown that abstract ornamentation, paradoxically,

conveys the ability to produce images by means of a set of references to external entities. But this paradox is only apparent by virtue of the inherent nature of the metaphor itself which, in order to explain the imaging system of this type of geometry, we must now discuss.

Indeed, the metaphor is basically a double entity insofar as the principle of its existence depends on a transfer of meaning between two terms. So it has both an intrinsic and an extrinsic nature, namely, its perceptual nature and its virtual nature. The two terms correspond precisely to the two domains of the metaphor, the literal domain which consists of its manifest material and determines the essential support of transfer, and the metaphorical domain which consists of the transferred significances or identities themselves. Since the required transfer, which produces the very sense or occurrence of the metaphor, is possible, both domains can be variously similar or distinct, i.e. not necessarily close entities. For example, they can be as distinct as those forming the visual metaphor in the Comares Hall, with one term presenting a morphology of a non-representational order (the endless space of the cupola), the other forming a kind of figuration of a positively representational order (the starry images).

So, to render the necessary transfer effective, the referential relationship between both terms has to be activated, whether they ontologically differ or not. To be more precise, the vehicle, i.e. the first term stimulating metaphorical activity, must be conceptualised in such a way that it presents a range of active references to the second term. This range of references yields the transfer of the latter into the former, and then generates a kind of identification between them at the last stage in the metaphorisation process. As we saw in the reception room of the Alhambra, the referential system corresponds to evocations full of imagery, through structural analogies and conceptual resonances arising from the interwoven semantics of the geometrical patterns and the textual pictures of the inscriptions. Thus, the stellar vocabulary, together with its centrifugal motion and the limitless aesthetic space of the ceiling initiate the process of identification between the dome and various images of cosmological entities, providing it with the aesthetic status of a cosmological metaphor.

In this double genre of abstraction and evocation, the art of the Al-hambra can be compared with the contemporary abstract paintings of Mark Rothko. (Plate XIV) Like the Comares dome, these works constitute double entities as visual metaphors which all rely on non-representational forms. What one immediately perceives in these paintings consists of the conjunction of polychrome pictorial planes, floating masses of deep colour that clearly do not represent anything, and are, quoting the artist's own words, 'without direct association with any particular visible experience'.[17] However, the abstract matter of Rothko's works hides various types of references by analogy, evocation or conceptual resonance, leading to the formation of diversified metaphors, biological, physical as well as metaphysical, metaphors of cosmogonies, aquatic metaphors, and so forth.

Returning to the imaging geometry in the Alhambra, an important point has to be made concerning the very function of this type of geometrical expression, invested as it is with such pictorial power. This function turns out to be readily understandable, as it supplies an alternative to direct representation which, as one knows, Islamic culture was reluctant to develop. At the same time, in respect of the general configuration of the Naṣrid palace, the imaging geometry maintains the general visual harmony based on variations of abstract geometrical patterns. (Plate XV) Actually, the fact that this type of geometry produces virtual images does not prevent it from providing the sense of sight with non-figurative forms that one can grasp and enjoy as such, namely pure geometrical patterns of an abstract order. This second possibility of reading the work of art exists thanks to the constitutive principle according to which any visual metaphor forms, by definition, a double aesthetic entity giving rise phenomenologically to a dual aesthetic experience.

In other respects, it is necessary to insist on the fact that this aesthetic system differs radically from observable representation, insofar as it does not yield the same kind of apprehension of the work of art. Representation designates and denotes its object and fixes its rules of designation and denotation in the visual configuration, whereas metaphor suggests its object and, resolutely inspirational, is essentially variational, leaving an active part to the individual subjectivity in the

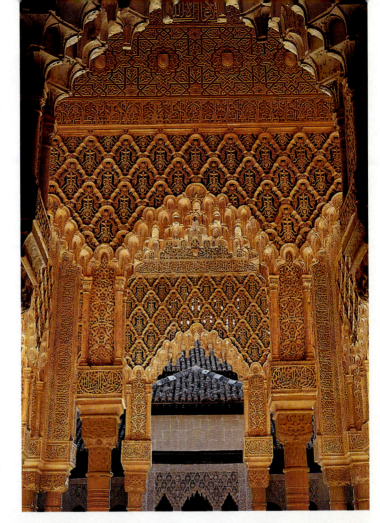

XII RIGHT.
Decorated arcades
of the Patio of the
Court of the Lions,
Alhambra

XIII BELOW. Detail
from the Court of
the Myrtles,
Alhambra

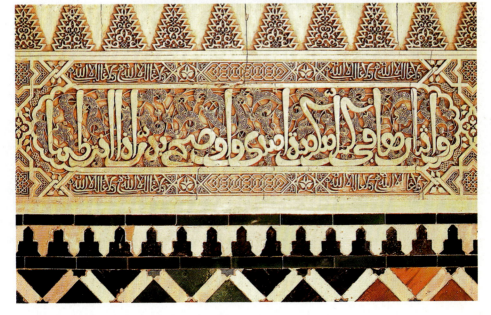

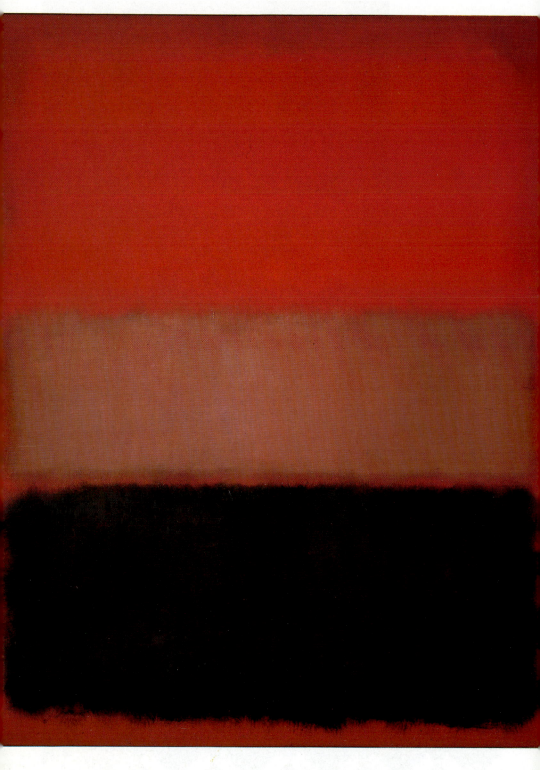

XIV No. 46 [*Black, Ochre, Red over Red*], Mark Rothko, 1957

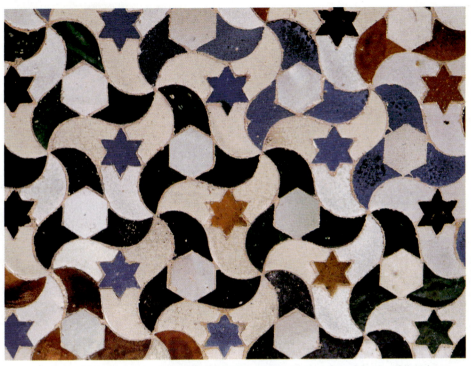

XV ABOVE. Polychromatic ceramic abstract tile pattern, Court of the Myrtles, Alhambra

XVI BELOW. Cupola of the Hall of the Two Sisters, Alhambra

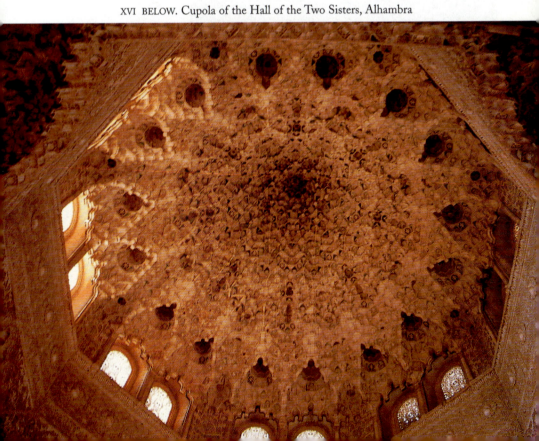

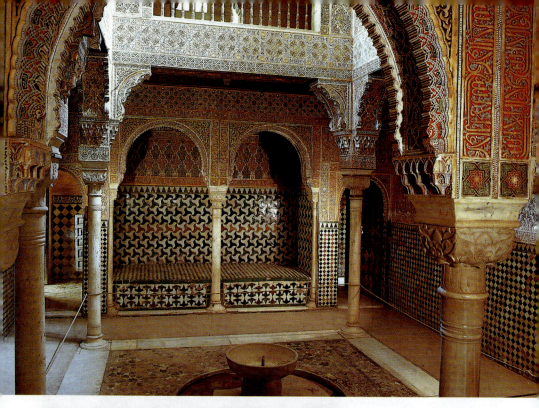

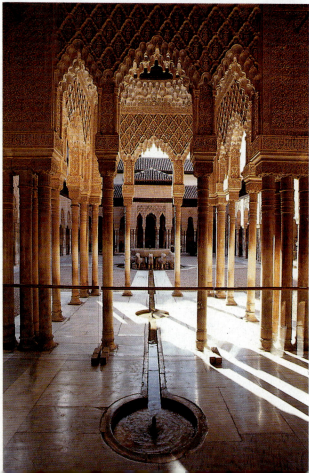

XVII ABOVE. The Royal
Bath, Alhambra

XVIII LEFT. Court of the
Lions, Alhambra

XIX Silver pot, Herat, 12th century CE

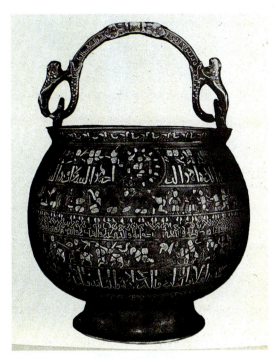

XX Bowl, Nishapur, Iran 9th-10th century CE

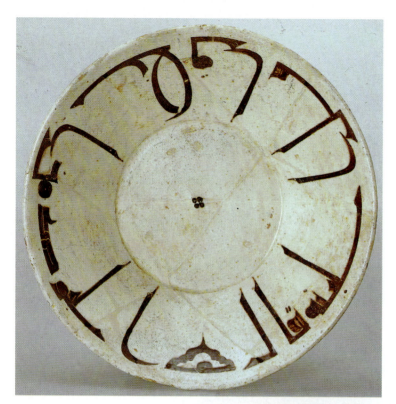

XXI Bowl,
Nishapur, Iran
10th century CE

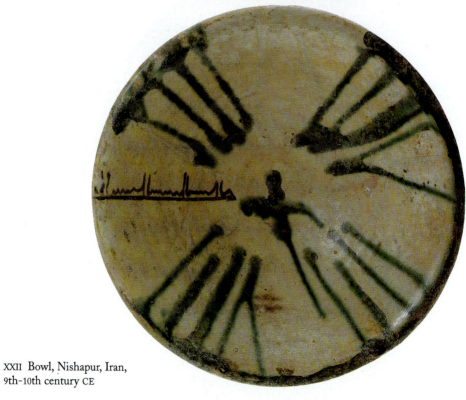

XXII Bowl, Nishapur, Iran,
9th-10th century CE

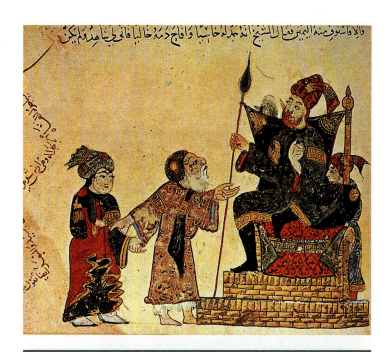

XXIII Miniature
from the *Maqāmāt*
of al-Harīrī
Baghdad, 13th
century CE

XXIV *City*, Edward
Ruscha, 1968, oil on
canvas

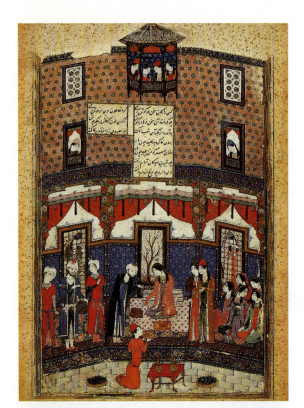

XXV Miniature, from Nizāmi's *Khusraw and Shirīn*, Tabriz early 15th century CE

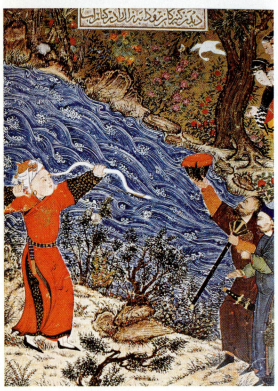

XXVI Miniature, *Shāhnāma*, Tabriz *c.* 1370 CE

perception process it induces. Consequently, the former constitutes a ready-made entity that appeals more to cognitive consciousness, 'a phenomenology of the mind', while the latter, never totally achieving its constitution, puts the viewer in a situation of oneirism, by strongly stimulating his dream consciousness, as 'a phenomenology of the soul'.[18] We can also state that, compared to the rational system of objective representation which is fundamentally a reality of matter, the visual metaphor is a reality of the imagination, a moving and fluctuating entity that constantly renews the terms of the experience it generates. By virtue of all these characteristics, the metaphorical expression of visual forms proposes a specific mode of figurability involving an unknown and undetermined part proper to oneirism. We could add to this definition of the properties of the visual metaphor a remark made by Gaston Bachelard concerning oneirism:

> One communicates to others only an orientation towards a secret without ever being able to tell the secret objectively. The secret never has complete objectivity. In this way, one orientates towards oneirism, one never accomplishes it.[19]

This short account using the example of the Comares Hall to demonstrate the aesthetic mechanisms subtending imaging geometry, logically leads one to raise the question whether there are other similar devices in the Alhambra. The hanging *muqarnas*-cupolas—namely the Ceiling of the Hall of the Two Sisters (Plate XVI) and the Hall of the Abencerrajes around the Court of Lions—are clearly another manifestation of this geometrical system. Considering their structural composition, these cupolas present an elaborate morphology drawn by the mathematical diffraction of prismatic overlapped volumes which constitutes the technical principle of *muqarnas* decoration in general. This character of three-dimensionality is the most obvious difference, among other distinctive properties, which distinguishes these cupolas from the Comares dome, despite the aesthetics common to both features. Immediately, the seemingly endless space of the wooden structure in the reception hall stands in contrast with the three-dimensionality of the *muqarnas* vaults, perceptually defined as corporated objects with outlines and limits.

This means that the category of imaging geometry comprises two types, two-dimensional and three-dimensional imaging geometries. The first is a metaphor of space, the others are metaphors of things or bodies, both working to exactly the same rules. They simply constitute particular cases with particular structures and contents of the same generic aesthetic proposition. So the issue now is the definition of these particularities, compared to the Comares device.

Once more, it is the articulation of the visual configuration of the two halls with the semantics of the inscriptions that allows us to classify these *muqarnas* features as imaging geometries or imaging geometrical metaphors. The content of the inscriptions themselves appear to be almost entirely poetic, with the exception of some repetitive pious phrases that one finds throughout the Alhambra. The absence of Qur'anic quotations makes sense insofar as these parts of the palace belong to the private area of the building, supposed to have been apartments, and so devoted to intimate activities. As we said previously with regard to the Comares Hall, such semantics correspond in the first instance to the practical function of these private rooms. Indeed, we immediately observe that the epigraphy inscribed all around the Court of the Lions is mainly profane in character, as opposed to the dominant religious and political character of the inscriptions in the reception hall, fitting its public usage.

Appropriately combined with the architectural space and features, the poems in the quarters of the Lions Court, as in the Comares Hall, form an artistic whole conceived with both textual and visual languages. They establish the same type of non-representational aesthetic relationship with the material configuration they praise, that is to say a relationship involving not a system of direct symbolisation between the different propositional terms (visual and textual), but a system of metaphorisation operating by a transfer of meanings and identities through a range of references. Before analysing it, let us quote the long poem written by Ibn Zamrak that extends from the Hall of the Two Sisters to the Hall of the Abencerrajes:

I am the garden appearing every morning with adorned beauty;
 contemplate my beauty and you will be penetrated with understanding;
I excel through the generosity of my lord the Imam Muḥammad for all
 who come and go;
How excellent is your beautiful building, for it certainly surpasses all others
 by the decree of the stars!
How many joyful solaces for the eyes are to be found in it; in it even the
 dreamer will renew the objects of his desire!
The hands of the Pleiades will spend the night invoking God's protection
 in their favour and they will awaken to the gentle blowing of the breeze.
In here is a cupola which by its height becomes lost from sight; beauty in
 it appears both concealed and visible.
The constellation of Gemini extends a ready hand [to help it] and the
 full moon of the heavens draws near to whisper secretly to it.
And the bright stars would like to establish themselves firmly in it rather
 than to continue wandering about in the vault of the sky.
Were they to remain in its antechambers they would outstrip the
 handmaidens in serving you in such a way as to cause you to be pleased
 with them.
It is no wonder that it surpasses the stars in the heavens and passes beyond
 their farthest limits.
For it is before your dwelling that it has arisen to perform its service, since
 he who serves the highest acquires merit thereby.
In [your dwelling] the portico has exceeded [the utmost limits] of beauty,
 while thanks to it the palace has come to compete in beauty with the
 vault of heaven.
With how many a decoration have you clothed it in order to embellish it,
 one consisting of multicoloured figured work which causes the brocades
 of Yemen to be forgotten!
And how many arches rise up in its vault supported by columns which at
 night are embellished by light!
You would think that they are the heavenly spheres whose orbits revolve,
 overshadowing the pillar of dawn when it barely begins to appear after
 having passed through the night.
The capitals [of the columns] contain all sorts of rare wonders so that
 proverbs [composed about them] fly in all directions and become
 generally known.

In it there is burnished marble whose light has shone and thus illuminated
the darkest shadows remaining in the gloom.

When they are illuminated by the rays of the sun you would think that
they are made of pearls by reason of the number of celestial bodies in
them.

Nor have we observed any palace higher in its lookout spots, clearer in its
horizons, or ampler in its hall of assembly.

Moreover we know of no garden more pleasant in its freshness, more
fragrant in its surroundings, or sweeter in the gathering of its fruits.

[The garden] gives double satisfaction for the amount which the judge of
beauty imposed on it [as a fine]:

For if the hand of the breeze fills it with [silver] dirhams of light, he is
satisfied with this [as payment];

Yet the [gold] dinars of the sun [also] fill the enclosure of the garden,
filtering through its branches, leaving it embellished.[20]

Within each room, the poetic semantics contain plenty of celestial
connotations and pictures that allow an identification of the cupolas
with some kind of galactic bodies. But they do not properly and directly
designate them as determined images of galactic bodies, so that onto-
logically each cupola is not a representation nor a symbol of some starry
morphology in the heavens, but only a fictive object that stimulates the
projective behaviour of the user, by suggesting or generating metaphori-
cally analogous images with what he can grasp, know or imagine while
looking at, or just thinking of the fascinating spectacle of the firmament.
This metaphorical identity of the cupolas lies in their specific visual con-
figuration, built on an intricate three-dimensional geometrical
composition that displays to the sight an astonishing rotating body, tend-
ing to grow like an organic being, penetrated by plays of light and
darkness, and animated by strong optical effects of undulating motion.
They offer marvellous visual spectacles, like the atoms of a universe in
formation, evoking the physical laws of cosmic bodies, whether real or
imagined: up and down movement, concentric attraction or, the oppo-
site, repulsion, fragmentation, diffractation, aggregation, play of light,
and so on. Like the Comares dome, they constitute double entities able
to embody any picture of a galactic formation and/or simply to propose

the visual enjoyment of their manifest appearance; pure geometrical intricacy provoking sensations of light, motion and combinations of abstract figures, lines and volumes.

The poetic text, however, inflects in a sense this phenomenon of mental projection by defining a specific metaphysical status for these metaphorical cupolas within the imaginary cosmic world composed by the artistic marvels of the Naṣrid complex. It actually locates them near to the constellations, within the same intermediary sphere as the small cupola of the throne alcove in the Comares Hall, that is to say, the sphere between the earthly world and the superior realm of the heavens. It means precisely that although the *muqarnas* vaults hold, at the physical level of the building's elevation, the same position as the wooden dome, i.e. the position of the main central roof of the room, they nevertheless do not carry similar metaphysical values and meanings, because of the inferior rank to which they correspond within the general hierarchic order of the cosmos.[21] In terms of cosmological evocation, the Comares ceiling is the unique culminating point of the whole palace and metaphysically the most elevated site; all the other covering features in the palace spread out beneath it.

From the evidence of all these observations, it clearly appears that there is no way of confusing the two types of device under consideration, or of distinguishing them simply at the perceptual level according to their three-dimensional or two-dimensional qualities and geometrical structures. Each type definitely conveys specific aesthetic meanings and identities, depending on the function of the room as well as the syntax of the visual and textual elements of the architecture. By extension—let us repeat—each arrangement induces a peculiar aesthetic experience of either a profane or politico-religious order, even though both cases share the same aesthetic rules proper to the imaging geometry system.

KINETIC GEOMETRY

In speaking about the optical effects of motion produced by *muqarnas* roofing, we come to the second category of geometrical design in the

Alhambra: kinetic geometry, namely a geometry that has movement as
its fundamental principle. This statement immediately prompts another,
which is that the geometry previously studied relates to kinetics in its
aesthetic conceptualisation. Accordingly, the *muqarnas* cupolas may be
considered as a combination of figurating and kinetic geometries, or
more exactly an imaging geometry concealing kinetic principles. How-
ever, among these subtly diversified compositions, one also finds a
separate proposition we designate as 'kinetic geometry', which has abso-
lutely no imaging property and which is consequently purely kinetic,
insofar as it remains totally abstract, forming not a double but a single
entity. The essential quality of this single entity is to concentrate all its
meanings and ontological identity in its literality, in its manifest consti-
tution. Since primordially 'geometry is a material ontology whose object
is determined as the spatiality of the thing belonging to Nature',[22] this
aesthetic application has for its object the spatiality of a particular thing
in Nature—the movement. We can name this second type of geometry
'kinetic geometrical abstraction'. It then remains to point out the areas
of the palace affected by these particular aesthetics and how they are
expressed.

The royal bath provides one of the greatest examples of this kind of
geometrical formation. (Plate XVII) Many horizontal panels inlaid in
the lower area of the walls within various rooms, some parts of the floor[23]
and the patio configuration of the quarter of the Court of the Lions
equally belong to the same category.[24] So, as in the case for the imaging
geometry, the kinetic type offers two particular versions of the same ge-
neric proposition: plane kinetic geometry on the walls, panels and floors,
and space kinetic geometry developed in the patio. We shall begin by
examining the first case.

Most of the geometrical panels covered with polychrome ceramic tiles
depict images of movement, and are hence classified in the kinetic cat-
egory. But here the term 'image' must be understood as a visual
expression, obviously not as iconography or a figurative picture. That is
to say that the perceptual content of these ornaments and their formal
structure constitute visual manifestations of the principle of movement.
Perhaps the simplest examples in terms of geometrical design, but also

the most radically kinetic ones from the strictly aesthetic point of view, are to be found in the baths, where the ceramic sets that adorn the walls follow a standard model of kinetic organisation.

The panel displays repeated elementary geometrical figures, all of the same shape and painted alternately in contrasting, vivid, primary colours that are regularly arranged on the surface in order to fill it completely, often leaving a white space between each figure. In this way, the white patterns radically oppose the black and coloured figures, producing a dramatic contrast with each other, strengthened by the play of bright, juxtaposed primary colours. In addition to this the simultaneously contrasting colours and black and white values, the repetition of the forms and their arrangement, systematically placed in alternation with, in some cases, a variation of linear direction, creates a strong linear and chromatic rhythm, an animation of the pictorial plane and a vibration of the surface which are all fundamentally effects of the principle of movement. A skilful dynamic mechanism is thus built by means of the basic two-dimensional visual elements of line, colour, light and dark values which actually sets the geometrical patterns in motion. Such a configuration immediately ascribes the work of art to an aesthetic realm of pure sensation and form in which it is movement itself that constitutes the required goal, the ultimate intention.[25]

In correlation, this aesthetic system initiates a specific perceptual phenomenon of a kinetic ocular excitation which is the sole expected perceptual response. In other words, the viewer's experience consists of the visual sensation of motion that this ornamentation produces through its materiality. There occurs no transfer process, no imaginary projection, only the immediate optical grasp of pure forms, of which the essence is movement that is rendered to the sight without intermediary or references: an aesthetic phenomenology involving a strictly sensorial experience based on the vital relationship between the object and the user's physical body through the sense of sight. The smallest movement, or the slightest lowering and opening of the eyes, activates this dynamic physical-optical relationship between the seer and the seen. In summary therefore, the essential meaning of these geometrical propositions resides

in the various expressions of movement, and the aesthetic experience they aim to stimulate is the optical delight of movement.

Such a visual language perfectly fits the practical function of the place for which it has been selected. In the bath, for example, it transforms the walls into animated screens that the eyes can enjoy, while the whole physical body gives itself up to the pleasures for which the building is designated, and thus provides a pleasing architectural framework. The inscriptions poetically describe and comment upon this activity and echo in literary terms this stimulation of the senses by the visual forms. In the other areas of the palace where one can contemplate similar ornaments, at the building's lower level on immediate contact with the architecture, the eye first lights upon the kinetic panels which immediately claim the attention. In a sense, the latter work as a sort of aesthetic warning, that prepares the viewer to be initiated into the full experience of the architecture. In this way, he finds himself immediately projected into a world of overwhelming artistic richness which he is then able to discover to the full.

As for the more sophisticated geometrical structures that one sees, for example, on the ceramic panels in the Mirador de Lindaraja, it appears more difficult to determine their exact aesthetic nature and meaning. Undoubtedly, they too conceal the kinetic properties of the juxtaposition of primary colours and the linear rhythmic value of the black and white relief. Given that they are arranged in continuity with the other panels in the general topography of the ornaments, they fulfil the same function of creating a stunning visual impact. However, their intricate unfolding, which involves an elaborate mathematical structure, tends to transform the physical kinetic field into a conceptual field of applied geometrical thought, insofar as movement is no longer the focal aesthetic principle, but a visual corollary of the material demonstration of a mathematic ideality. Therefore, these particular geometrical propositions imply a perception that no longer operates exclusively in the concrete and somatic world of the senses, but equally in the abstract and mental sphere of the intellect. More exactly, they both use the language of pure material form as a self-referential entity and the conceptual form as an embodied idea or a materialised ideality. Consequently, unlike the

radical kinetic formations and the imaging geometry, they define themselves as double entities, acting and signifying within the double aesthetic field of matter and concept. This aspect concerns the third axis of our investigation, conceptual geometry, but there first remains the task of analysing the space-kinetic geometry developed in the Court of the Lions. (Plate XVIII)

The same aesthetic principle of movement that governs space-kinetic geometry applies to three-dimensional kinetic geometry. Thus, the courtyard comprises an intricate system of arches sustaining four porticoes and two pavilions symmetrically disposed around two crossed axes. The mathematical tabulation that distributes the numerous thin columns and the scheme of arches, their height, profile and size, produces an intensively modulated linear and spatial rhythm. This rhythm, in three dimensions, plays with a subtle alternation between emptiness and fullness, opening and closing, light and darkness, and wide and narrow spaces, a kind of visual music with highly varied notes. Moreover, the projection of the two pavilions within the court introduces another type of alternation, that of forward and backward planes. The centre, underlined by the imposing fountain, forms the focal point of the general distribution of all these elements. In itself, such a disposition that emphasises the rhythmic and alternative architectonic order, is absolutely kinetic, phenomenologically kinetic we should say, independently of any interpretation concerning the assumed representational meaning of the courtyard as an 'image of Paradise'.[26] Nevertheless, this kinetism draws all of its aesthetic power and significance from the viewer's sight and depends fundamentally on his bodily behaviour within the architectural space.

As a matter of fact, following the simplest objective law of pure kinetic phenomenon, three-dimensional geometry spreads itself in space, and moves and changes its structure according to the point of view from which it is contemplated, in reality, in interrelation with the user's physical location within the court and his selective visual attention. As long as the latter executes the least footstep, the least motion, a basic activity in such a place, the geometrical configuration changes scheme and perspective in terms of optics. Considering the multiplicity of alternations

of the elements, their complex combinations and perspective variety, these optical changes diversify considerably in accordance with the corporal rhythm and the topography of the body's movement and gestures: a virtual diversification constituted by a series of successive visual sequences in which the centre itself shifts its position from the middle to the corners, fancifully breaking the symmetry of the organisation of the court. This knowledgeable and positively efficient kinetism constitutes an artistic phenomenon that, by the way, all photographers attempt to show through their pictures, and that any camera achieves by means of the so-called 'panning technique', so eloquently expressed by the French *balayage optique.*

Finally, this space geometry possesses an objective, intrinsic and permanent aesthetic movement that transforms itself, in the viewer's eye, into an experimental and circumstantial movement. Therefore, we can assert that it is doubly kinetic, namely objectively and empirically kinetic, and that ontologically it has a double existence, both objective and subjective.

These are the defining terms of three-dimensional kinetic geometry in the Alhambra and of the primal aesthetic experience that phenomenologically everyone has while walking in the Patio of the Lions. Such terms were consciously conceived and manifest the intentions of the original conceptualisation of the site. They perfectly fulfil the expectations linked to the usual function of many palatine courtyards, that is to say to provide a beautiful, pleasant and enchanting area for walking, physical enjoyment and entertainment, involving above all the sense perceptions and bodily behaviour. But though we have focused our analysis on this particular aspect of the court, it is obvious that it lends itself to many other reflections and interpretations, notably those concerning its possible metaphysical connotations. This problematic, however, supplies a separate subject of study.

CONCEPTUAL GEOMETRY

In the Alhambra, the conceptual geometry subtends various ceramic and stucco panels, but it shows its more ample developments in the most

preciously decorated parts, like the Comares Hall walls and those supporting the *muqarnas* cupolas. The term 'conceptual' means the main principle that determines this geometrical system, which is clearly not movement, neither pure formalism, nor metaphor, but the aesthetic expression of the concept of geometry as an ideal object, an ideality produced by the mathematical thought, 'the higher forms of products of reason'.[27] Not only are these geometrical propositions obviously founded on this mathematical thought, but also their artistic finality and signification lie entirely in it, insofar as their aesthetic nature is totally ideal. Like all mathematical objects, this type of geometry can ontologically define itself in these terms:

> Its being is thoroughly transparent and exhausted by its phenomenality. Absolutely objective, i.e., totally rid of empirical subjectivity, it nevertheless is only what it appears to be. Therefore, it is always already reduced to its phenomenal sense, and its being is, from the outset, to be an object (*être-objet*) for a pure consciousness.[28]

Consequently, unlike either of the previous cases of imaging and kinetic geometry, there is no difference between the means and the goal, those terms of the artistic process being exclusively one and the same thing. What conceptual geometry aims at transmitting is pure geometrical thought through a visual artistic expression, a material manifestation at this very last stage of the connection between the prior idea and its embodiment in visible forms which corresponds to the fusion point between the two. To express through a materialised demonstration the geometrical objectivation as an originally pure product of the intellect, and to supply an embellished form, i.e. a form invested with a perceptual beauty, to its mathematical essence: this is the founding aesthetic purpose of the conceptual geometry in the Alhambra. At a more general level, the aesthetic logic of any conceptual art consists in offering to any type of abstract thought or concept the possibility of a sensible manifestation, according to a transposition process of an abstract thinking into a visual thinking. Such a process, which makes the artistic matter tend fundamentally towards abstraction, finds in the Moorish palace its best support in two-dimensional spaces. Therefore, in it, only surfaces

include conceptual geometrical formations. But how can one in practice recognise the latter and discern it from the other types of geometry? That is the question.

The answer is not obvious, nor is it easy to respond to this question because the architectural configuration subtly crosses the different systems. For a better grasp of the conceptual ornaments, one must rely on two criteria. The first is a rather elaborate mathematical structure that confers on the panel the credible identity of an ideal geometrical proposition. The second is logically the lack of imaging properties and a non-prevalence of kinetic qualities, even if in some specimens, such as the ceramic sets in the Comares Hall, the conceptual geometry appears not to be free of a truly kinetic character. Nevertheless, in these cases, kinetism constitutes a perceptual effect *a posteriori* of a specific visual configuration, but does not itself take part in the ornament conceptualisation as an absolute priority, as is the case in the bath decoration. The essential artistic purpose and sense in turn remain a mathematical demonstration.

Once the conceptual geometrical thematic is identified, the analysis can be focused on two major distinct points. The first refers to the comprehension of its numerical system, in the same way in which one studies working geometrical drawings, but in this case, drawings that display beauty to the sight by means of high contrasts of bright colours or sometimes calligraphic and vegetable decorative patterns. The second point concerns the philosophical value conveyed by the geometrical concept diffused throughout the artistic medium, that is to say, the reflection on the concept of geometry itself as an ideal object which is 'always based on the morphological idealities of imagination and sense'.[29] Obviously, as Grabar has remarked, the geometrical ornament of the Alhambra cannot be only an attractive combination of shapes. Its extensive use in the building undoubtedly conceals the cognitive function of making it the receptacle of these idealities, through philosophical connotations, resonances and values: through, for instance, its metaphysical connections with notions such as order or harmony, and its commitment to the dialectics between the finite and the infinite, for 'geometry is possible ..., since phenomenology's basic principle of finitude always interacts

with an infinite (and non-objective) ideal pole—here, our earth—the zero-point of all perception, "the infinite horizon" of every object'.[30]

This complex reflection presupposes the analysis of the conceptual geometry in the perspective of its entire intellectual Islamic context, of global knowledge of philosophy, theology and science from which the geometrical practices were developed. Necipoğlu fully expounds this contextual problematic of Islamic architectural geometry in *The Topkapi Scroll*. Without tackling this vast question, we will assert that in the particular work of the Alhambra, conceptual geometry has a definite philosophical function, insofar as it necessarily activates, through the visual artistic medium, these philosophical connotations and resonances of geometrical thought and ideality. It emanates a geometrical vision of the world understood through the objectivity of mathematical thought which, by definition, transcends time and space; this transcendental ontology of geometry thereby confers on the Alhambra a certain universal value, which the German phenomenologist Edmund Husserl defines with an admirable lucidity:

> But geometrical existence is not psychic existence; it does not exist as something personal within the personal sphere of consciousness: it is the existence of what is objectively there for 'everyone' (for actual and possible geometers, or those who understand geometry). Indeed, it has, from its primal establishment, an existence which is peculiarly super-temporal and which—of this we are certain— is accessible to all men, first of all to the actual and possible mathematicians of all peoples, all ages; and this is true of all its particular forms.[31]

But such a cognitive process is not uniform throughout the whole building, by virtue of the aesthetic conditioning of the artistic matter itself. In fact, the conceptual geometry becomes inevitably coloured by the specific semantics of the general topography of the place in which it appears, these semantics being—as we demonstrated—powerfully modelled according to the syntax between the pure formal configuration and the epigraphy, and depending on the architectural function. The sum total of these highly determining elements necessarily and strongly inflect the cognitive phenomenon, orientating it in diversified

philosophical directions of religious, metaphysical, cosmological or aesthetico-poetic orders.

Let us illustrate our argument again with the example of the Comares Hall. The huge conceptual spaces on the walls, above the alcoves, that prepare the viewer for the overwhelming vision of the dome, undoubtedly absorb the metaphysical emanations of the room, transforming them into projection screens of cosmological thoughts. Indeed, to reach the ineffable plane of the endless vault, starting from the rational plan of the material world down below, the viewer's vision has to traverse these transitory fields formed by vast, blind, calm, static and limitless areas crossed by tiny intricate lineaments infinitely expanding; mathematical materialisation of the concept of absolute space where perception abstracts itself after having left the bright, animated and vividly coloured realm of the lower level. These conceptual fields of the Comares Hall are, in summary, a geometry of the spiritual path from physics to metaphysics, from matter to the highest abstract spheres.

In the Court of Lions complex, the panels beneath the *muqarnas* cupolas function according to a similar aesthetic system. Nevertheless, given the general visual context, they emanate a conceptual language related to the particular notion of the poetic and oneiric marvellous, derived from what we could call 'the astral imaginal', hierarchically distinct from the 'heavenly or metaphysical imaginal' in the superior degree. Anyway, this language is naturally linked to the universal metaphysical signification of the Naṣrid building as a metaphor of an Islamic cosmogony. And whether they concern one or the other architectural configuration, in accordance with this overall signification, the conceptual geometrical propositions shape visual spaces of mathematical abstraction which are destined to shift the perception and the aesthetic appreciation from the sensitive level of corporeal existence to the cognitive level of the mind, the intellect and the spirit. They are phenomenologies of the spirit that complete the phenomenologies of the senses and the phenomenologies of the soul, respectively constituted by kinetic and the imaging geometrical propositions. In the Alhambra the combination of them all permits a total aesthetic experience of geometry as a mode of artistic expression.

As we have seen, the diversified geometries of the Naṣrid palace propose a kind of aesthetic comprehension that implies a multiplicity of enjoyments related to each other in a channelled way, or more precisely, a multiplicity of experiences that can be realised without interruption, occurring within the same fictive world created by a complete abstract system. So the viewer experiences various sensations, intellections and imaginative projections, from an intellectual realm of pure ideas and concepts (conceptual geometry), to another realm firmly rooted in the corporeal world (kinetic geometry), going through a field which lies at the margins of figuration and representation (imaging geometry). The building thereby keeps its perceptual character of wholeness, while it produces cognitions of all the philosophical orders that the artistic representation of the Islamic power it embodies has to explore.

5

The Signifying Aesthetic System
of Inscriptions in Islamic Art

Words, words are shells filled with sounds. Within the miniature of a single word, how many stories there are!

Gaston Bachelard[1]

This fifth chapter, we will devote to the study of inscriptions from the perspective of the overall aesthetic question of the meaning of artistic creation in Islam. As typical Islamic art forms, both inscriptions and calligraphy have been widely analysed by scholars from the point of view of their spiritual resonance as well as their symbolic, pedagogic, mystic and purely perceptual values, depending on the function of the artefact or the building they decorate.[2] But even if we are well acquainted with these questions, the aesthetic language implemented in calligraphic works remains difficult to grasp while considering their relationship with the visual media. Indeed, as it appears in our chapter on the Comares Hall in the Alhambra for example, the medium itself constitutes a distinct aesthetic entity with which the decorative writing maintains a meaning-specific link, based on a combination of the semantic properties of both the textual and the visual significance of the work of art. It is especially on this aesthetic link, i.e. the signifying system of inscriptions, that our enquiry will focus. Three topics will be considered: inscriptions

and their visual surroundings, Samanid ceramics with calligraphic deco-
ration, and inscriptions in the figurative illustrations in books.

INSCRIPTIONS AND THEIR VISUAL SURROUNDINGS

It is commonly thought that relative to the universal problem of repre-
sentation raised by the arts in general in Muslim culture, inscriptions act
as a substitute for the figurative image in the works of other great civili-
sations. Indeed, they possess a figurative power that generates a kind of
virtual imagery in the sphere of the sensible in which they occur, elo-
quently called 'the image of the word' by Dodd and Khairallah.[3] This
singular aptitude derives from the universal psychic phenomenon of visu-
alisation produced by the vocable, a phenomenon that Wittgenstein states
rhetorically:

> 139... What really comes to mind when we understand a word?—Is it not
> something like a picture? Can it not be a picture?[4]

Notably in the realm of the sacred, Islamic inscriptions replace the
usual imagery within other cultural contexts as pedagogic instruments
for transmitting a religious message through visual forms. In addition,
they are sometimes invested with an *iconographic*[5] function (to borrow
Oleg Grabar's qualification), within a formally abstract artistic configu-
ration, i.e. a configuration free from objective figurative representation,
like the parietal poems in the Alhambra:

> There are inscriptions (in the Alhambra) that can be called *iconographic*,
> for they can be shown to have been chosen in order to emphasize some
> special purpose of the building or to make an association that is not obvi-
> ous *a priori*.[6]

More precisely, this iconographic potentiality of certain inscriptions,
especially the poetic ones, serves to elaborate the imaging visual meta-
phor, as we described in the third chapter in relation to the Comares
Hall of the Alhambra and certain other Islamic masterpieces.[7]

However, this definition is not entirely accurate as it is not always pos-
sible to reduce a complex phenomenon in artistic terms. First of all, this
definition tends to present the inscription simply as a substitute or

equivalent of a picture, as if by merely substituting one for the other one would find the same signifying logic subtending two types of artistic work which would differ only through their formal constitution. But if we examine the Islamic epigraphic system more carefully, we can immediately observe that it has little in common with traditional figurative representation and its non-representational or decorative context. Usually, the figuration at the centre of the aesthetic system of a work of art constitutes the exclusive medium that produces signification, insofar as pictures objectively signify by designation, that is by telling stories, depicting situations and things, or conveying symbolic content through recognisable signs. This is according to the founding principle stated, again, by Ludwig Wittgenstein:

> 389... It is in the nature of representation to be the representation of this and of nothing else. One could be thus led to consider representation as a super-portrait.

And further on, he states:

> 523—The picture tells me—(what it is) itself—I would like to say. The fact that it tells me something consists in its own structure, in its forms and its colours.[8]

Thus, pictures definitely confer a secondary aesthetic status on their surroundings. The so-called 'decorative elements' or non-representational elements that may coexist with them are devoid of all sense as they do not apparently tell or express anything significant or directly nameable. Additional and unnecessary elements, pleasant but meaningless ornaments, these simply secure the embellishment of the representation and have no artistic purpose in themselves. Consequently, if one unconditionally accepts the interpretation of inscriptions as substitutes for pictures, one implies that they would convey, through their literal content, the whole or an essential part of the artistic sense of the medium in which they occur. Their decorative surroundings would merely provide an attractive framework for perceptual enjoyment or form a secondary aesthetic field, subordinated to the predominant one, that of epigraphy. By extension, without inscriptions, the decorative set would

lose all or the essential part of its signification. How could this idea fit in with the Islamic arts that have developed, as everyone knows, ornamentation as a major mode of expression? There is no need to insist here on the fact that Islamic ornaments cannot be simply and solely understood through their perceptual qualities and their ability to produce beauty. And to point out a crucial question which we referred to in the fourth chapter: can geometry be considered a mere exercise of ornamental virtuosity? Does it not elicit higher forms of cognition as epigraphy does?

Such an approach, then, leads unavoidably to a systematic explanation of the sensible forms through their epigraphic content and a confusion of textual cognitions with visual cognitions. Moreover, this infers that epigraphy automatically transfers scriptural meaning into formal surroundings as if it were not an autonomous artistic entity governed by proper aesthetic laws and logic. In its venerable and beautiful lettering, calligraphy would explicitly formulate the aesthetic intention, the content and the *raison d'être* of the whole artefact it adorns, conveying the most elevated sense that it would inculcate in the latter, as if it would instil life into it.[9] In other words, calligraphy would merely tell everything about the work of art, properly naming its meaning according to a signifying system analogous, or even identical, to that of a page from a book or other non-artistic media for writing. We recall here the metaphor of the 'open book' that scholars used to apply to some masterpieces full of scriptural signs for pointing out the remarkable specificity of Islamic inscriptions as an aesthetic cognitive means. Clearly we cannot deny that Islamic epigraphy, like Latin inscriptions in Roman art or hieroglyphs in Egyptian sculptures, manifests in many artistic media the cognitive intention of transmitting a message of a strictly linguistic order. Starting from this, Oleg Grabar has classified this type of writing under the category 'informative inscriptions'.[10] This is the case, for example, of artistic features related to worship and authority like the *miḥrāb* in mosques or the cupola in the Dome of the Rock[11] in which the decorative writings completely fulfil the linguistic function of determining the eminently religious and/or political sense of the work of art. But equally, the cognitive mechanism of Islamic epigraphy goes beyond this traditional and universal function of writing in visual arts, forming in

fact an original, diversified and polyvalent semantic relationship to the configuration in which it operates.

Whereas the traditional system of representation through material images is determined by a constant, fixed and unidirectional language according to which these images carry exclusively the aesthetic signification—as we mentioned above—writings and other devices of Islamic works of art define many-sided, mobile and flexible combinations following diverse motivations and an extremely variable signifying power that emanates from both the scripture and the artistic form. This variability is due to what we can designate 'the behaviour of epigraphy', depending on whether it fully takes part in the decoration, or whether it invades it or appears separately from it. Both the textual and visual features can equally share, or on the contrary appropriate for themselves, the semantic and perceptual functions in the language of the artistic work. In our analysis of the Comares Hall, we have already shown how the inscriptions participate in the process of fashioning the building into a cosmogony, but this in full accord and complementarity with the purely visual cognitive system, i.e. without modifying the perfectly independent and auto-signifying sensible field of the architecture.

With regard to the same palace, there exists more evidence of this aesthetic autonomy of both modes of expression, evidence of an historical order. In his book *Nafḥ al-Ṭīb*, the historian al-Maqqarī tells the story of a poem written by one of the poets who composed literary works for the decoration of the Naṣrid complex, Ibn al-Khaṭīb:

> One of the best works that came from Lisan al-Dīn's pen (Ibn al-Khaṭīb)
> is the celebrated *qaṣīda lāmiyyā* that he addressed to the sultan when the
> latter returned from Morocco to al-Andalus. ... One tells how the sultan,
> because of the admiration it produced, ordered this *qaṣīda* to be inscribed
> in his palaces in the Alhambra and (it is said) that up to now it continues
> to be inscribed in the said palaces...'[12]

This historical account underlines the fact that by virtue of this phenomenon of autonomy, some inscriptions could be conceived independently from their visual support, with no necessary link nor

having any particular semantic connection with the latter, except the general status of royal symbol shared by both artistic works.

In other respects, in line with their capacity for aesthetic metamorphosis and together with the ambiguity of the sense they are supposed to provide, inscriptions can blend completely with the other elements of artistic vocabulary. In this way, they themselves become pure ornaments, or ornaments with a deliberately hidden or induced meaning. From this standpoint we can question or interpret many inscriptions in Hispano-Moorish and Timurid architecture, for example. Furthermore, inscriptions can completely lose their custodial function of objective linguistic signalling in favour of their decorative capability, transforming themselves into the meaningless epigraphic type called 'pseudo-Arabic'. This type is frequently used in the adorning of metalwork items, such as those from post-Saljuq Iran which feature the so-called 'animated style' of calligraphy, characterised by zoomorphic and anthropomorphic letters. (Plate xix) More subtly, in many ambiguous epigraphic cases we can ask whether, despite the legibility of their content, there is not a degradation of the sign-expression of a pure signification into a simple sign-indication, of a clear intention into an empty symbol. Could this be the case, for instance, in the endlessly repeated decorative words like '*Allāh*' and '*Baraka*', or the parietal slogan of the Naṣrid dynasty '*Lā ghāliba illā Allāh*' ('There is no victor but God') in the Alhambra.

These observations underline two obvious and important facts that one must take into account when studying decorative scriptures in Islam. The first is that the signifying potential of the inscriptions depends upon aesthetic variability. The second is that this potential does not *necessarily* have a link with the textual content itself. In short, it is primarily the entire aesthetic configuration of the inscriptions that activates their signifying potential. At this point in our enquiry, we will cite concrete examples through which some of our arguments will be demonstrated, beginning with Samanid ceramics from Nishapur and Samarkand (third/ninth and fourth/tenth centuries), with their spectacular calligraphic patterns. (Plates xx, xxi, xxii)

THE SIGNIFYING SYSTEM OF INSCRIPTIONS ON SAMANID CERAMICS

The production of ceramics with exclusively or predominately calligraphic decoration in Central Asia under Samanid rule provides substantial material for our enquiry. One does not know exactly what the exact function of these ceramics was, but since they are made of ordinary material, generally earthenware covered with white slip (*engobe*) and adorned with writings painted in black, brown and red,[13] they probably served for common use. The inscriptions, stemming from the literature of proverbs and ethical theorems, free of religious sentences or Qur'anic quotations, are apparently of a profane order, supporting the idea of their belonging, in their genuine historical context, to the commonplace. This seems especially true if one compares them to contemporary production from the Abbasid court, which show finer materials denoting a much higher technical level.

However, these modest wares do not cease to impress and amaze observers by the high quality of their aesthetics based on the visual impact of calligraphic forms. Did not the scholar Arthur Lane claim lyrically and without particular scientific consideration that they were the 'essence of Islam in the pure state'? Indeed, some of the best specimens[14] seem to radiate a sort of spirituality, even if by that we are only stating a subjective impression from a contemporary viewpoint with our perception conditioned by the practice of artistic observation. The fact is that, with great economy of means, these Samanid ceramics display an ability to transform a simple item into a genuine work of art simply by skilfully exploiting the perceptual properties and plastic possibilities of the material at hand. Their great aesthetic effectiveness proceeds from the utterly minimalist character of their decoration and form that ultimately permits the calligraphy to exercise a maximal force of expression. The aesthetic language of these objects must therefore be deciphered.

As always with the aesthetic study of epigraphy, there are two aspects to be examined: what is offered to the sight and what is said strictly in terms of linguistics. Then it is a question of understanding the sense-relation between both types of cognition in order to grasp the whole meaning of the artistic work. Beginning with the linguistic content, we

stated above that it tends to deal with the popular literature of maxims, little poems and other adages, or single words with religious or ethical resonance, like *baraka*, often repeated several times on the same surface. But one also finds cases of meaningless inscriptions written in pseudo-Arabic, writings that are almost illegible by virtue of the excessive decorative distortion of the letters, and incomplete sentences needing guesswork or deduction of their semantics. In this latter case, there are two possibilities. Either the calligraphic line starts somewhere in the centre and spreads on one side of the object only, or it runs across it and appears cut off at the edges.[15]

Thus, these inscriptions may literally teach us nothing that was not known through popular wisdom, through the linguistic phenomenon of reiteration or by common oral expression. From this observation, we can assume that the textual semantics as such have relatively little importance. By extension, it would be excessive, if not wrong, it seems to us, to assert that Samanid ceramics supply a formal basis for communicating this type of popular knowledge. We can just suppose that those ceramics on which either part or the whole of the epigraphic content is hidden constitute in fact a sort of linguistic game or even joke, deliberately trifling with the primal cognitive function of the words and undermining their ontology, in a certain way, by the removal or mutilation of that which originally makes sense of them. Or maybe they conceal an intention to bring out the secret dimension of a partially-delivered message, in the poetic sense, following the French poet Mallarmé's statement: 'To name an object is to remove three-quarters of the poem's delight which consists in guessing little by little.'[16]

Consequently, epigraphic semantics do not constitute valid reliable proof for understanding the signification of this work of ceramic. At the same time, the writings certainly provide a pretext to practise calligraphic drawing. Thus, it is rather the aesthetic result of modelling the whole object as a scriptural medium with the particular corporeality of calligraphy that produces the meaning.

In fact, since the visible possesses its own language, these items induce a perception of the calligraphic work in which modalities can not only integrate an effective reading, but above all transcend it. To a very

high degree they play upon this ambivalence resulting from the dialectic tension between the abstract and the formal, between the ideality of sense and the reality of the sign that characterises the art of inscriptions. Obviously these objects focus upon the pure material beauty of calligraphy as such in order to produce maximum visual impact by emphasising their perceptual qualities through various aesthetic methods. By radically contrasting dark values with the clear underlying colour, the inscription allows the body of its linguistic units to show up on the blank space. It also variously works its outlines, thickness and decorative elements, becoming in this way much more a thing itself than an abstract sign naming something. Actually, the known principle by which words are also objects cannot find a better fitting than in these works which give to the letters the substantiality and the aesthetic behaviour of figurative elements and assign to them the artistic role of iconography, in the full sense of the term.

Nevertheless, to display a sort of visual show of Arabic calligraphy certainly does not constitute the sole reason for the remarkable aesthetic effectiveness of these Samanid ceramics. Another, and probably the most important cause, lies in their strange capacity to transform the prosaic material support into a true, total and polysemic fiction, thanks to pure aesthetic manipulation, again not to specific literary compositions. The best example of this phenomenon is a series of dishes with highly contrasting black and white decoration.

The epigraphy draws black or dark letters on the pure white or clear background, as if suspending the words above an invisible horizon. In this strange manner, it manifests itself in the most expressive power of its forms, namely the original power of expression emanating from the line of the *qalam* to which the calligrapher or scribe gives birth on the virgin surface of the book, conscious of the elevated, almost 'sacred' sense of his gesture. Naked and neutral, the white ground of the modest ware becomes like a blank page or a painter's canvas, an abstract site of indefiniteness that the sole formal presence of the letter and the single dark trail of the writing tool fill with significance, without specific consideration to literal meaning. In the case of the inscriptions spreading horizontally, often transgressing the physical limits of the artefact and

amplifying its aesthetic openness, the phenomenon becomes more striking. Concerning the specimens with a band of Kufic writing, Lisa Golombek rightly pointed out the possible influence of the textiles decorated with *tirāz* patterns that do indeed present a similar spatial combination of the ground and the decorative scripture:

> The plate is like a pure-white linen cloth across which runs a thin *tirāz* band. This comparison may seem far-fetched, but not if one considers the custom of covering objects with napkins (*mandīl*). Consider the following scenario. (Although this reconstruction is a fantasy, there are numerous texts describing the serving of beverages from covered vessels.) A servant brings his master a goblet of water or other drink carried on an inscribed plate. The goblet is covered by a *tirāz*-ornamented linen *mandīl.* The servant removes the goblet and gives it to the master. The inscription on the plate is now visible. The napkin is then replaced, but directly over the plate. The inscriptions on the napkin and the plate spatially coincide.[17]

We will go further and say that all idea of the functionality of the object, its own reality and its practical identity, disappears under this process of transfiguration by the letter that transforms the background of the dish into a pure aesthetic space, more precisely, a scriptural conceptual aesthetic space in the pure phenomenological sense, as Jacques Derrida explains:

> Linguistic incarnation and the constitution of written or scriptural space suppose, then, a closer and closer 'interconnection' of ideality and reality through a series of less and less ideal mediations and in the synthetic unity of an intention. This intentional synthesis is an unceasing movement of going and returning that works to bind the ideality of sense and to free the reality of the sign. Each of the two operations is always haunted by the sense of the other: each operation is already announced in the other or still retained in it.[18]

On this scriptural space, spatiality of origin, ground-body of the graphic sign as a morphological ideality, the inscription embodies the primal act of writing and recovers its primordial ontology prior to all particular literary intentionality or 'intentional primordiality of a Here-and-Now

of truth',[19] hence its transcendental value, its essence. As Jacques Derrida, again, says:

> Writing, as a place of absolutely permanent ideal objectivities and therefore of absolute Objectivity, certainly constitutes such a transcendental field (a 'subjectless transcendental field' according to Jean Hyppolite's expression)... writing is no longer only the worldly and mnemo-technical aid to a truth whose own being-sense would dispense with all writing-down. The possibility or necessity of being incarnated in a graphic sign is no longer simply extrinsic and factual in comparison with ideal Objectivity: it is the *sine qua non* condition of Objectivity's internal completion.[20]

Thus, as a site of reactivation of the primordial signification of the act of writing and the presence of writing itself, the Samanid artefact *a fortiori* conceals or emanates, like distant echoes, sacred or spiritual reminiscences. This recalls Lane's utterance quoted above. Indeed, it is quite impossible to pass over the fact that this artefact was conceived in an Islamic civilisational context in which, after spoken language, the graphic symbol is fundamentally the universal and visible location of an uncreated and revealed truth, the religious truth. Calligraphy, above all, constitutes 'the visible body of the divine Word'.[21] So that inscriptions, including these, that reawaken the primordiality of the sense of writing, 'a sense that is conserved as a sedimentary habituality and whose dormant potentiality can *de jure* be reanimated', also further reawaken its religious essence, namely the factual and contingent embodiment of the divine Word in the sensible spatio-temporality of speech and scripture. Additionally, whether it formulates a religious thought or not, the epigraphy on the Samanid pieces, embellished with the highest calligraphic beauty, appears aesthetically with the same sublimating perceptual qualities as the Qur'anic scriptures themselves. They still continue to refer to the primary and greatest significance of the Islamic graphic symbol, the embodiment of the divine Truth, and show a way of constantly evoking the founding text of Islam.

On particular ceramics that have been decorated with concentric calligraphy, the inscriptions operate to achieve the same aesthetic 'reduction' of the object into a phenomenal field wherein the ideality of

sense is gathered into scriptural signs. They create strings open to re-production *ad infinitum* and, in this way, as in the other examples, they transform the utilitarian object into a limitless and abstract aesthetic space. Nevertheless, taking into consideration the curved body of the item, they involve a gesture that does not follow the *natural* direction of writing free from the physical constraints of the scriptural basis. They follow, rather, directions derived from the medium morphologically defined by roundness and circles—and so a non-neutral support—introducing and emphasising spatial concepts of the centre, the circumference and the periphery. In some cases, the sensible notion of centrality is subtly pointed out by a little graphic dot in the middle of the artefact and the radiation effect appears stressed by the specific shape of the letters *alif*. Vlad Atanasiu underlines this effect, which he interprets in a personal manner: 'The circular reading provokes an hallucinatory twisted effect in which the *alif*s are paths toward the mystic implosion in a central point.[22]

This means that, unlike the horizontal writings that deny all corporeality to their basis, these concentric inscriptions, by exploiting the artefact morphology, partly restore to it its real definiteness and objective identity. Consequently, they emphasise more than other examples the grounding process of sense in the physical territory in which they deposit it, namely the graphic symbol and its material basis, through which sense is set down in the world. However, this circular territory, virtually moving and expanding from the centre to the indefinite edge, remains out of the given world insofar as it does not apparently refer to any existing thing: a work of pure creation again, a genuine product of imagination.

Finally, if these Samanid ceramics amaze and impress, it is not so much for their authentic beauty as much as for their audacious manner of going against the hierarchic logic relative to the common conception of 'thinghood', according to which a very modest item of daily life, made of poor material, is the object least likely to receive the most elevated artistic gesture, in this case, the skilful gesture that repeats analogously the placing of the sacred Word in the corporeality of the letter.

INSCRIPTIONS IN THE FIGURATIVE ART OF MINIATURES

In Islamic culture, inscriptions occupy a great proportion of the pictorial space in figurative representations. Among other types of figuration, there are, of course, the miniatures wherein they frequently appear completely integrated into the painting. Such a combination raises numerous questions inherent to the concept of figuration in general, most notably concerning that which seems to be a true alienation of the latter to scriptures. Here, however, we will focus only on the purely perceptual role calligraphy performs, independent of its corollary, namely the difficult problem of the combined visual and textual semantics.

Calligraphy inserted within an image induces a perception of the entire artistic work and a particular kind of reading of the writing which depends on the aesthetic nature of the picture. The latter can be clearly two-dimensional or show a tendency towards perspective by introducing three-dimensional elements to combine with the formal construction of the calligraphic frieze that basically proceeds from the aesthetic concept of two-dimensionality.[23] In other words, the visual composition formed by the scriptural and the figurative vocabulary, changes according to each of the two pictorial orders mentioned. By extension, the whole aesthetic system of the work of art changes too, that is to say both its cognitive production and the perceptive mode it implies.

In the first case of two-dimensional representation, such as that found in Arab miniatures and in many early Persian paintings from the Middle Ages, the inscription appears in visual continuity with the linear distribution of the figurative patterns.[24] (Plate XXIII) The text thereby stresses the flattening of these patterns on the page surface, while they themselves prolong, in a sense, its linearity. By translating the letters into a representational graphism which forms backgrounds acting out the narrative of the inscription, this type of miniature plays a game of interaction between the text of the image and the image of the text. Such a deconstructive game that merges two different languages, usually used separately, also characterises the paintings of Edward Ruscha, the American Pop artist who uses writings and words as figurating subjects. (Plate XXIV) In an exhibition of Ruscha's work, the critic Thierry Raspail very

clearly analyses this aesthetic phenomenon that relates equally to Islamic medieval miniatures, except that in these, it is the inscription which transforms itself into a kind of figuration, not the other way around:

> Ruscha does not hesitate to write the subject, to inscribe the text which is to be its figure. Standing as the sponsor of a form of visibility that can be read, he hazards only an act of translation of one form in another. By making the visible indistinct from the legible he displaces the sphere of language to that of painting. Surreptitiously he manufactures allegory: the figuration here is but named, there is a figuration inherent to the discourse and a discourse of the figure.[25]

As a matter of fact, this process imposes an overall mode of understanding the picture that follows the rules of *reading* and eradicates those of visual projection within the realm of corporeal things, i.e. the fictive spatiality usually proper to the world of images. The picture does not perform the traditional role of the fragment cut out of the field of the visible, but draws a topography by a juxtaposition of various isolated elements, exactly as the succession of scriptural characters with which it forms a syntax of linguistic order. The figurative patterns name, through their recognisable forms, the represented objects insofar as, adding the one to the others, they operate a type of meaningful designation similar to designation by sentences. In this way, the gaze immediately apprehends analogously this figurating graphism and the writings, by grasping their outlines inscribed on the page, again by *reading* them.[26]

Consequently, we can assume that in a sense, in such cases, the figuration is truly submitted or subordinated to the order of literality which specify the textual signs. In this way, it loses much of its aesthetic autonomy. The calligraphic texts that act as the complementary cognitive means of the illustrated literature itself, constitute the predominant signifying premise of the miniature, and it is primarily through the reception of their semantics that penetration into the imaginary field of the book occurs. Whereas the picture may tend to secure the cognitive function of visual confirmation of the textual content, it may also eventually serve as the aesthetic function in the embellishment of the manuscript.

In the second category of three-dimensional representations, to which

Timurid paintings belong along with the miniatures of the modern period in general, the pictorial and scriptural grounds present a dichotomy. As the two-dimensional morphology of calligraphy opposes the illusionist three-dimensional space of the picture, the whole field of the artistic work breaks up into two distinct visual sequences, each governed by its own laws. So the significance of the miniature comes of two separate vectors which are almost autonomous of one another, the script and the painting. (Plates xxv, xxvi) Within the whole signifying system of the illustrated manuscript, the image tends to be free from the *diktat* of the writing, and equally of the text itself. The picture is then in a propitious position to project the reader into the invented world of the visual illusion, making him jump without transition, on the same page, from the surface of the graphic plane to the depth of space. Such a conjunction of two aesthetic languages induces *a fortiori* a double perception of the miniature: the strictly cognitive perception of ideas, thought and narration through the texts, and imaginative projection into the visual fictitious space of the figuration. In other words, *grosso modo*, we return to the traditional signifying system proper to the illustrated album that combines the two worldly visions, the one modelled by the narration, and the other modelled by the image. However, even this type of Islamic miniature remains original and specific in its manner of articulating these distinct visions, insofar as they are never liberated from each other, the inscription still being co-substantial to the iconography.

Since the Muslim painters dared to venture into the marvellous world of three-dimensional illusion, they did not hesitate to manipulate perspectivist techniques. They did so according to their own approach of course, not from a realistic point of view as in Western civilisation, but in order to elaborate new imaginary spatialities, notably inspired by Chinese painting.[27] Playing with the bi-polarity of two-dimensional calligraphy and the three-dimensional spaces possible in pictures, they devised combinations, depending on whether the epigraphic theme asserted its presence or, on the contrary, was discretely placed within the miniature. Without successfully severing its links with calligraphy, the iconography shares with it the entire pictorial plane of the page, in such a way that inscriptions serve only a marginalised function, namely an

informative function that only aims to provide semantic terms for the understanding of the miniature. In this case, the scriptures appear circumscribed inside cartouches, panels or as friezes set back from the image, alongside its edges. The terms of the message emanating from these texts do not modify the aesthetic vision that the picture itself proposes. This marginal position constitutes the equivalent to that characterised by the writings in the ancient arts of Antiquity.

In addition to this style, there exist some paintings that simultaneously exalt the aesthetic and signifying potential of both the calligraphic and figurative vocabulary. Among the most striking examples of this phenomenon are the Iranian gouaches on paper from the nineteenth century. One sees some genre scenes of bucolic backgrounds against which appear, as superimposed, huge Arabic characters.[28] These works force the gaze to move by 'travelling' from the foreground occupied by large, thick, black scriptural units, toward the background of animated landscape that the small size of the patterns renders remote, vague and vanishing. This fanciful three-dimensional optical effect is outlined in the pastel colours of the picture strongly contrasting with the black of the calligraphic signs. The passage from one plane to another nevertheless occurs subtly, despite the great opposition in the treatment of both spaces and the double reading it generates. Indeed in some areas, the letters carry, in the heart of their circumvolutions, fragments of this oneiric landscape which properly belong neither to the calligraphy nor to the horizon of the phantasmagorical view. These fragments, floating among letters, form a kind of intermediary space and thereby create a smooth transition between the foreground and the remote background of the composition.

One also finds works which, by means of this dual-section aesthetic system, highlight the calligraphic bodies. This is accomplished by painting, within the margins of these gigantic bodies, microscopic scenes that occur in a natural setting. These scenes introduce into an otherwise three-dimensional spatiality, at least a backing field, by virtue of clear values contrasting with a flattening monochrome black ground that determines, in silhouette, the letter-shapes. However, such a flattening process joined to the disproportion between the large script and the tiny scene,

emphasises the inscription's two-dimensionality on the pictorial surface that the eye initially grasps; the gaze then moves toward the tiny images inside the letter-forms.

Finally, whenever these images combine themselves with writing, calligraphy forms a positively determining role within the aesthetic language of Islamic figurative art, even if it allows the figuration to enjoy fully its powers of expression as an autonomous fiction. Consequently, we can say that inscriptions occupy the figurative field in a way that is as penetrating as in the realm of ornamentation. As legible signs, they easily elude interpretation, being suspended between formalism and sense, between significance and insignificance. Didactic instrument, poetic imagery or pure ornament, they are aesthetically unclassifiable insofar as they appear polyvalent, ultimately fulfilling all aesthetic functions. The polysemic link binding them to their material configuration, especially geometrical networks, seems to be an area of a dynamic and reciprocal transfer of meanings, alternately filling or emptying both fields with a sense of variable orders, religious, poetic, pedagogic, oneiric, and so on. Rather than a scriptural version of visible figuration, Islamic calligraphy constitutes an autonomous aesthetic system which combines and articulates itself to another system, similarly autonomous and autosignifying, both composing the visual language of their medium.

Notes

1. Definition from Robert Audi, ed., *The Cambridge Dictionary of Philosophy* (Cambridge, Mass., 1997), p.10.

2. Elianes Escoubias, quoted by Maryvonne Saison, in 'Le Tournant esthétique de la phénoménologie', *Revue d'esthétique et phénoménologie*, 36 (1999), p.126. For an epistemological study of this method of understanding art, see also the numerous articles in *L'Art au regard de la phénoménologie* (Toulouse, 1994).

3. José Miguel Puerta Vílchez, *Historia del pensamiento estético árabe, al-Andalus y la estética árabe clásica* (Madrid, 1997).

4. Edgar de Bruyne, *Études d'esthétique médiévale* (Paris, 1998), 2 vols.

CHAPTER 1

BEAUTY AND THE AESTHETIC EXPERIENCE IN
CLASSICAL ARABIC THOUGHT

1. Ibn Sīnā, *Kitāb al-najā*, ed. Majīd Fakhrī (Beirut, 1985), p.282.

2. See Introduction. These two works are essential to our argument.

3. We have not included Sufi thought and poetics here, despite the fact that it obviously contains profound aesthetic arguments. Aesthetics in Sufism is a complex subject that deserves a special study of its own.

4. This treatise has been partially translated into English by Abdelhamid I.

Sabra, *The Optics of Ibn al-Haytham* (Kuwait and London 1983–1989), Books I–III. See also, by the same author, 'Sensation and Inference in Alhazen's Theory of Perceptual Vision', in Peter K. Machamer and Robert G. Turnbull, eds, *Studies in Perception: Interrelations in the History of Philosophy and Science* (Columbus, 1978), pp.160–85.

5. The *Ṭawq al-ḥamāma* has been translated into English by A.J. Arberry as *The Ring of the Dove* (London, 1953).

6 Text quoted in Spanish and Arabic by Puerta Vílchez, *Historia del pensamiento estético árabe*, pp.513–14.

7. Aristotle, *Rhetorics*, I, 9, 1366, in Jonathan Barnes, ed., *The Complete Works of Aristotle.* 2 vols. (Princeton, N.J., 1991), vol. 2.

8. Puerta Vílchez, *Historia del pensamiento estético árabe*, p.507.

9. Ibid., p.506.

10. See Abderrahman Badawi, *La Transmission de la philosophie grecque au monde arabe* (Paris, 1958).

11. See de Bruyne, *Études d'esthétique médiévale*, vol. 2, ch. 1, 'L'Esthétique de la lumière'.

12. See, ibid., vol. 2, ch. 8, 'L'Esthétique visuelle', p.239.

13. We will consider this second aspect, the objectivist vision of the world, with the rational philosophers, Ibn Rushd and Ibn al-Haytham.

14. Ibn Sīnā, *Kitāb al-najā*, pp.281–2, quoted by Puerta Vílchez, *Historia del pensamiento estético árabe*, pp.587–8.

15. Quoted by de Bruyne, *Études*, vol. 2, p.399.

16 Ibn Sīnā, *Kitāb al-najā*, p.281.

17. Ibid., p.281.

18. Ibid., pp.321–2.

19. Ibid., p.282.

20. Aristotle, *Topics*, VI, 7, in Barnes, ed., *The Complete Works of Aristotle*, p.146.

21. See for example Alain de Libera, *Averroès, l'intelligence et la pensée, Sur le De Anima* (Paris, 1998).

22. Ibn Rushd, *Faṣl*, quoted by 'Abderrahman Badawi, *Histoire de la philosophie en Islam*, (Paris, 1972), vol. 2, pp.776–7.

23. Ibid., p.808.

24. Ibn Rushd, *Paraphrases in Libros Rhetoricum Aristotelis*, ed., 'Abderrahman Badawi (Cairo, 1960), p.96, 12–21, 'Commentaire d'Aristote, Rhétorique, 1371 b 4–10', translated from Arabic into French by Maroun Aouad (forthcoming). Dr Aouad kindly gave me the text in both languages.

25. Ibn Rushd, *Talkhīṣ kitāb al-ḥāss wa'l-maḥsūs*, in *Arisṭuṭālīs fī'l-nafs*, ed., A. Badawi (Beirut, 1980), p.198.

26 De Bruyne, *Études*, vol. 1, p.314.

27. See de Libera, *Averroès, l'intelligence et la pensée.*

28. See in particular Umberto Eco, *The Aesthetics of Thomas Aquinas* (Cambridge, Mass., 1988).

29. See Badawi, *Histoire de la philosophie en Islam*, vol. 2, pp.815–16.

30. Ibn Haytham, *Kitāb al-manāẓir*, vol. 1, ch. 5, quoted in n. 7 by Puerta Vílchez, *Historia del pensamiento estético árabe*, p.689.

31. The first three volumes of this seven-volume treatise were translated with commentary by Abdelhamid I. Sabra, *The Optics of Ibn al-Haytham*, 1-3, *On Direct Vision*. 2 vols (London, 1989).

32. See the passage of Ibn al-Haytham's *Discourse on Light*, quoted by Sabra, in *The Optics of Ibn al-Haytham*, 2, pp.9–10.

33. From Puerta Vílchez, *Historia del pensamiento estético árabe*, pp.689–90.

34. See the excellent recent book by Elaheh Kheirandish, *The Arabic Version of Euclid's Optics* (Kitāb Uqlīs fī'Ikhtilāf al-Manāẓir). 2 vols (Cambridge, Mass.,1999).

35. See the list of these properties by Ibn al-Haytham and their effect on perception in Sabra, *The Optics of Ibn al-Haytham*, I, pp.200–3, and Puerta Vílchez, *Historia del pensamiento estético árabe*, p.698.

36 Ibn al-Haytham, *Kitāb al-manāẓir*, II, p.227, in Sabra, *The Optics of Ibn al-Haytham*, I, p.136, and quoted by Puerta Vílchez, *Historia del pensamiento estético árabe*, p.696. See also Sabra, 'Sensation and Inference in Alhazen's Theory of Visual Perception', in *Studies in Perception: Interrelations in the History of Philosophy and Science* (Columbus, 1978), pp.160–84.

37. Ibn al-Haytham, *Kitāb al-manāẓir*, vol. 2, p.308, in Sabra, *The Optics of Ibn al-Haytham*, II, p.200.

38. Ibid.

39. Ibid., p.201.

40. Grosseteste is cited by de Bruyne, *Études*, vol. 2, p.121.

41. See *Opticae Thesaurus, Alhazen Arabis libri septem nuncprimum editi. Eiusdem liber de Crepusculis et Nubium ascensionibus. Item Vitellonis Thuringopoloni libri X*, ed., F. Risner, (Basilea, 1572), fasc., ed. D.C. Lindberg, (New York, 1972); D.C. Lindberg, 'Alhazen's Theory of Vision and its Reception in the West', *Isis*, 58 (1967), pp.321–41, and his *Theories of Vision from al-Kindī to Kepler* (Chicago, IL., 1976).

42. See de Bruyne, *Études*; Erwin Panofsky, *Meaning in the Visual Arts* (Chicago, IL., 1982), notably pp.88–92; Eco, *The Aesthetics of Thomas Aquinas*.

43. De Bruyne, *Études*, vol.2, p.123.

44. As Sabra states, Ghiberti copied parts of the *Optics* in his *Commentarii* from a fourteenth-century Italian translation, *The Optics of Ibn al-Haytham*, 2, p.97.

45. Ibn Haytham, *Kitāb al-manāẓir*, II, p.314, in Sabra, *The Optics of Ibn al-Haytham*, vol. 1, p.205.

46. Maurice Merleau-Ponty, *Phénoménologie de la perception* (Paris, 1945), p.65.

CHAPTER 2

THE AESTHETICS OF THE SOLOMONIC PARABLE IN THE QUR'AN

1. Al-Ghazālī, *Mishkāt al-anwār*, French tr. René Deladrière, *Le Tabernacle des lumières* (Paris, 1981), p.41.

2. Valérie Gonzalez, *Le Piège de Salomon, La Pensée de l'art dans le Coran* (Paris, 2001).

3. Qur'an, English tr., Ahmed 'Ali (Princeton, N.J., 1989).

4. Jacob Lassner, *Demonizing the Queen of Sheba: Boundaries of Gender and Culture in Post-biblical Judaism and Medieval Islam* (Chicago and London, 1993).

5. 'Bilqīs' is the name given to the Queen of Sheba in Islamic sources. It is not mentioned in the Qur'an.

6 See Mohammed Arkoun, *Lectures du Coran* (Paris, 1982) and his *Essais sur la pensée Islamique* (Paris, 1984); John Wansbrough, *Qur'anic Studies: Sources and Methods of Scriptural Interpretation* (Oxford, 1977); John Renard, *Seven Doors to Islam: Spirituality and the Religious Life of Muslims* (Berkeley, Calif., 1996).

7. See 'Aesthetics' in Audi, ed., *The Cambridge Dictionary of Philosophy*, pp.10–11; Marc Jimenez, *Qu'est-ce que l'esthétique?* (Paris, 1997).

8. Priscilla Soucek, 'The Temple of Solomon in Islamic Legend and Art', in Joseph Gutmann, ed., *The Temple of Solomon* (Montana, 1976), pp.73–123.

9. Priscilla Soucek, 'Solomon's Throne/Solomon's Bath: Model or Metaphor?', *Ars Orientalis*, 23 (1993), p.112.

10. See Haim Schwarzbaum, *Biblical and Extrabiblical Legends in Islamic Folk Literature* (Waldorf-Hessen, 1982); Max Seligsohn, 'Solomon in Rabbinical Literature and Legend', *Jewish Encyclopaedia* (New York and London, 1905), vol. 2, pp.438–44; Laurent Cohen, *Le Roi Salomon* (Paris, 1997); David Sidersky, *Les*

Origines des légendes musulmanes dans le Coran et dans la vie des prophètes (Paris, 1933).

11. Among numerous references, see Maria Jesus Rubiera, 'Salomon el gran constructor', in *La arquitectura en la literatura árabe, Datos para una estética del placer* (Madrid, 1988), p.45.

12. See Na'ama Brosh and Rachel Milstein, *Biblical Stories in Islamic Paintings* (Jerusalem, 1991); Serpil Baggi, 'A New Theme of the Shirazi Frontispiece Miniatures: The Divān of Solomon', *Muqarnas,* 12 (1995), pp.101–11; Norah M. Titley, *Persian Miniature Painting* (London, 1983), p.68.

13. About this tradition see Lassner, *Demonizing the Queen of Sheba.*

14. Tha'labī quoted in Lassner, *Demonizing the Queen of Sheba*, pp.187–202.

15. See al-Maqqarī's text quoted by Rubiera, *La Arquitectura en la literatura árabe*, pp.68–9.

16 Quoted in Rubiera, *La Arquitectura en la literatura árabe*, p. 87.

17. The inscription is mentioned by several scholars, among them Emilio García Gómez, *Poemas árabes en los muros y fuentes de la Alhambra* (Madrid, 1985), pp.121–2; Macario Golferich, *La Alhambra* (Barcelona, 1929), p.186.

18. See Oleg Grabar, *The Alhambra* (Sebastopol, Calif., 1992), p.101.

19. About this type of language, especially concerning religious topics, see Paul Ricoeur, *La Métaphore vive* (Paris, 1994); Northrop Frye, *Le Grand code* (Paris, 1984).

20. See, for example, the definition of the word by the great traditionist Muḥammad b. Ismā'īl al-Bukhārī, *Les Traditions Islamiques* (Paris, 1984), vol. 2, pp.409–10.

21. For the detailed interpretation of the meanings and connotations of this word, see Jacqueline Chabbi, *Le Seigneur des tribus, l'Islam de Mahomet* (Paris, 1997), p.515, n.228. See also Afif Bahnassi, *Dictionnaire trilingue des termes d'art, français-anglais-arabe* (Beirut, 1981).

22. This term attempts to translate the French phenomenological expression '*une donnée imageante*'.

23. Michael Baxandall, *Patterns of Intention* (Yale, C.T., 1985).

24. See 'Omeyyades', in Dominique and Janine Sourdel, *Dictionnaire historique de l'Islam* (Paris, 1996).

CHAPTER 3

UNDERSTANDING THE COMARES HALL IN THE LIGHT OF PHENOMENOLOGY

1. Gaston Bachelard, *La Poétique de l'espace* (Paris, 1978), p.40; English tr., Maria Jolas, *The Poetics of Space* (Boston, 1994).

2. See Rubiera, *La Arquitectura en la literatura árabe.*

3. See Grabar, *The Alhambra.*

4. For the inscriptions in the Alhambra see Grabar, *The Alhambra*; Garcia Gomez, *Poemas árabes en los muros y fuentes de la Alhambra*; Nykl, 'Inscripciones árabes de la Alhambra y del Generalife', *al-Andalus*, 4, (1936), pp.174–203.

5. For a theoretical definition of the various representational styles in art, see Nelson Goodman, *Langages de l'art* (Nîmes, 1990), Ch. 1, 'Refaire la réalité'.

6. See Rubiera, *La Arquitectura*, p.150; Dario Rodriguez Cabanelas, 'La antigua polichromía del techo de Comares en la Alhambra', *al-Andalus*, 35 (Granada, 1970), pp.423–51.

7. On the problem concerning the relationship of sense between texts and visual forms in Islam, see Valérie Gonzalez, 'The Aesthetics of Islamic Art: Toward a Methodology of Research', *al-'Uṣūr al-Wusṭā, The Bulletin of Middle East Medievalists*, 7 (1995), pp.28–9.

8. Ludwig Wittgenstein, *Tractatus logico-philosophicus*, French tr., Pierre Klossowski (Paris, 1961), p.64.

9. Concerning these features, see Valérie Gonzalez, *Emaux d'al-Andalus et du Maghreb* (Aix-en-Provence, 1994), pp.166–9.

10. Obviously it concerns existence as conceived through the Islamic religious and ethical criteria of the Middle Ages.

11. Qur'an 65:12.

12. See Edith Jachimowicz, 'Islamic Cosmology', in Carmen Blacker and Michael Loewe, eds, *Ancient Cosmologies* (London, 1975), pp.143–71.

13. *Rasā'il Ikhwān al-Ṣafā'*, I, p.277, quotation from Puerta Vílchez, *Historia del pensamiento estético árabe*, p.202.

14. On the philosophical debate on phenomenology and ideal objects like geometry, see the 'Preface' by John P. Leavey, in Jacques Derrida, *Edmund Husserl's Origin of Geometry: An Introduction*, (Lincoln and London, 1989), pp.12–13.

15. Nykl and Bargebuhr are two scholars who have worked on the Alhambra.

16. Grabar, *The Alhambra*, pp.118–19.

17. Dario Rodriguez Cabanelas, *El techo del Salon de Comares en la Alhambra, Decoración, Policromía, Simbolismo y Etimología* (Granada, 1970).

18. See Qur'an 53:14.

19. Arthur Danto, *La Transfiguration du banal*, French tr., Claude Hary-Schaeffer (Paris, 1989), p.205; English edn, *The Transfiguration of the Commonplace* (Cambridge, Mass., 1981). On the theoretical problem of representation and artistic identification, see the latter and also Goodman, *Langages de l'Art*.

20. Ludwig Wittgenstein, *Philosophical Investigations*, English tr., Gertrude E.M. Anscombe (Oxford, 1972), p.86; see also William H. Brenner, *Wittgenstein's Philosophical Investigations* (Albany, N.Y., 1999), p.40.

21. Wittgenstein, *Philosophical Investigations*, p.202.

22. See Derrida's reflection following his assumption: 'we will see that the infinite had already broken through, was already at work, when the first geometry began—that it, too, was already an infinitization', in Derrida, *Edmund Husserl's Origin of Geometry*, p.37.

23. Danto, *La Transfiguration*, p.151. See also below other remarks on the crucial problem of margins in art, pp.199–202.

24. Michael Fried, *Three American Painters* (Cambridge, Mass., 1965), quoted by Danto, *La Transfiguration*, p.149.

25. About this specific approach of the phenomenology of houses and buildings as places of anthropo-cosmologic projection, see Bachelard, *La Poétique de l'espace*, Ch. 1, 'La Maison de la cave au grenier', and Ch. 2, 'Maison et univers'.

26. Baxandall, *Patterns of Intention*.

27. See the following informative articles: Anne Davenport, 'The Catholics, the Cathars, and the Concept of Infinity', *Isis*, 98 (1997), pp.263–95; John Murdoch, 'Infinity and Continuity', in *The Cambridge History of Later Medieval Philosophy* (Cambridge, 1982), pp.564–91; and for a modern philosophical reflection on these concepts, Bertrand Russell, *Our Knowledge of the External World* (London, 1922), pp.189–213.

28. Bachelard, *La Poétique de l'espace*, p.12.

29. *Rasā'il Ikhwān al-Ṣafā'*, I, p.113, quoted by Puerta Vílchez, *Historia del pensamiento estético árabe* p.189.

30. Bertrand Russell, *The Analysis of Mind* (London, 1921), p.209.

31. Ibn Rushd in his Commentary on Aristotle's *De anima*, vol. 3 (429 to 10–435 b 25), de Libera *Averroès, l'intelligence et la pensée*, pp.144–5.

32. Ibid., pp.117–18.

33. Ibn Rushd develops the discussion on the cogitative faculty, after the example given by Aristotle, of the soldier who does not see but imagines that

there is a fire in the towers of the city; in de Libera, *Averroès, l'intelligence et la pensée*, pp.143–4.

34. Wittgenstein, *Philosophical Investigations*, p.206; for a further exploration of this fascinating mental mechanism, see the second part of this text.

35. See Hans Sluga and David G. Stern, eds, *The Cambridge Companion to Wittgenstein* (Cambridge, 1996); Ludwig Wittgenstein, *The Blue and Brown Books* (2nd edn, Oxford, 1960).

36 Wittgenstein, *Philosophical Investigations*, p.200.

37. Bachelard, *La Poétique de l'espace*, p.17.

38. The so-called '*métaphore imageante*' by the French phenomenologists.

39. Wittgenstein, *Philosophical Investigations*, p.198. On mental images according to this philosopher, see Donna M. Summerfield, '3. Fitting versus tracking: Wittgenstein on representation', in Sluga and Stern, eds, *The Cambridge Companion to Wittgenstein*, pp.110–12.

40. We noted Yves Klein's phrase as a quotation near one of his pictures at the Guggenheim Museum, New York, during the exhibition 'Abstraction in the Twentieth Century', April 1996.

41. Wittgenstein, *Philosophical Investigations*, p.205.

42. See Puerta Vílchez, *Historia del pensamiento estético árabe*, p.394, where he provides an important text by Hāzim al-Qartājānnī about this concept within the philosophical context of an aesthetic argument.

43. Alexander Nequam, *Speculum speculationum* (Oxford, 1988), p.191, quoted by Davenport, 'The Catholics, the Cathars, and the Concept of Infinity', p.277.

CHAPTER 4

ABSTRACTION, KINETICS AND METAPHOR:
THE 'GEOMETRIES' OF THE ALHAMBRA

1. Michel Serres, *Les Origines de la géométrie* (Paris, 1993), p.130.

2. Gülru Necipoğlu, *The Topkapi Scroll: Geometry and Ornament in Islamic Architecture* (Santa Monica, Calif., 1995).

3. Antonio Fernandez Puertas, *The Alhambra: From the Ninth Century to Yūsuf I* (London, 1997). See Oleg Grabar's review, 'A Paradise of Reflections', in *The Times Literary Supplement* (7 Nov. 1997), pp.12–13.

4. See for example, Issam el-Said, *Islamic Art and Architecture: The System of Geometric Design*, ed. Tarek al-Bouri and Keith Critchlow (London, 1993); Maria

Teresa Perez Sordo and Pablo Nestares Pleguezuelo, *Tramas geométricas en la decoracìon ceràmica de la Alhambra* (Granada, 1990); Sergei Chmelnizkij, 'Methods of Constructing Geometric Ornamental Systems in the Cupola of the Alhambra', *Muqarnas*, 6 (1989), pp.43–9; Luciano Boi, *Le Problème mathématique de l'espace, une quête de l'intelligible* (Berlin and Heidelberg, 1995); Marius Cleyet-Michaud, *Le Nombre d'or* (Paris, 1973).

5. Once again we have to emphasise the need to re-think the methodology of this type of analysis, so true is it that when aesthetics is applied to Islamic art in terms of an intellectual field typical of the modern Western world, it raises scepticism. This is a point that we develop in detail in the first chapter 'Préliminaires épistémologiques' of our book cited in the second chapter, *Le Piège de Salomon*. We should remember that this book contains an extended aesthetic study of the Qur'anic verse 44:27.

6. Serres, *Origines*, p.21.

7. Ibid., p.57.

8. See, for example, the exhibition catalogue by Mark Rosenthal, *Abstraction in the Twentieth Century: Total Risk, Freedom, Discipline* (New York, 1996).

9. Grabar, 'A Paradise', p.13.

10. Ibid.

11. *Muqarnas* are decorations made of gathered prismatic volumes in a honeycomb formation.

12. See Alpay Ozdural, 'Omar Khayyam, Mathematicians and *Conversazioni* with Artisans', *Journal of the Society of Architectural Historians*, 54 (1995) pp.54–71; Necipoğlu, *The Topkapi Scroll*, Ch. 8, 'Theory and Practice: Uses of Practical Geometry'.

13. Wittgenstein, *Tractatus Logico-Philosophicus*, p.36.

14. *Rasā'il Ikhwān al-Ṣafā'*, I, pp.79–80, quoted by Puerta Vílchez, *Historia del pensamiento estético arabe*, p.186.

15. For this reason the study of geometry in the Alhambra needs to be further developed; here we only state its basic geometrical system.

16. See the complete historical and aesthetic analysis of the arabesque patterns, in Necipoğlu, *The Topkapi Scroll*, part 2, 'The Discourse on the Geometric Arabesque'.

17. Quoted from Hervé Vanel, 'Rothko artiste du yo-yo', in *L'Oeil*, 502 (1999), pp.39–40.

18. On the difference between these phenomenologies, their properties and experiential implications, see Bachelard, *La Poétique de l'espace*, pp.30–1.

19. Bachelard, *La Poétique de l'espace*, p.31. We cannot resist quoting here also a passage from a literary work by the French poet Sainte Beuve that Bachelard cites (p.31), for it gives a perfect idea of the effect one could expect from the visual metaphor, 'Let the image float in you; go through lightly; the least idea will be enough for you'.

20. From Grabar, *The Alhambra*, pp.116–17.

21. On the cosmological order, see Ch.3 of this work.

22. Derrida, *Edmund Husserl's Origin of Geometry*, p.32.

23. Almost nothing remains of the original Naṣrid floor, but what there is, is enough to assume that it belongs to this geometrical type.

24. Here we must take into account, of course, the historical fact that, in several places, these panels were repaired or remade after the Naṣrid period. However, the aesthetic logic which it is possible to grasp from the original parts of the building allows us to think that, in terms of aesthetic conceptualisation, no significant changes were brought about. In the majority of the cases the replaced panels are obviously poorer artistically but conceptually equivalent to the old ones.

25. For a better understanding of this type of aesthetic system, we again refer to contemporary artistic work. The geometrical art of the Alhambra shares many aspects in common with so-called 'kinetic art', beginning with Neo-Impressionism, and French artists such as Georges Seurat and Paul Signac. These artists were theoreticians of what they called 'scientific chromatism', basically involving the principle of movement in visual arts. From that period, this principle was widely explored by artists belonging to various trends, from Northern Expressionism and geometrical abstract art, to the particular group of artists properly called 'kinetic artists', like Cruz-Diez, Soto, Yacov Agam, Vasarely and many others. For an excellent monograph on this subject, see Frank Popper, *L'Art cinétique* (Paris, 1970).

26. We do not agree with this well-known paradisal interpretation of the Court of the Lions, but there is no need at present to tackle this specific problem which would require a separate study. As it appears phenomenologically to the eye, and as it is perceptually conceived, the patio constitutes first and foremost a strong kinetic geometric arrangement, and that is the only point we wish to discuss here.

27. Edmund Husserl, *Cartesian Meditations: An Introduction to Phenomenology* (The Hague, 1970), p.78. The same author defines the geometrical concepts in phenomenological terms: 'Geometrical concepts are "ideal" concepts, they

express something which one cannot "see"; their "origin", and therefore their content also, is essentially other than that of descriptive concepts as concepts which express the essential nature of things as drawn directly from simple intuition, and not anything "ideal",' quoted in Derrida, *Edmund Husserl's Origin of Geometry*, p.134.

28. Ibid., p.27.

29. Quoted from the 'Preface' by John P. Leavey, in Derrida, *Edmund Husserl's Origin of Geometry*, p.16.

30. Ibid., pp.14–15.

31. Quoted from Husserl's original text, in Derrida, *Edmund Husserl's Origin of Geometry*, p.160.

CHAPTER 5

THE SIGNIFYING AESTHETIC SYSTEM OF INSCRIPTIONS IN ISLAMIC ART

1. Bachelard, *La Poétique de l'espace*, p.164.

2. See Erika Dodd and Sheila Khairallah, *The Image of the Word* (Beirut, 1981); Annemarie Schimmel, *Calligraphy and Islamic Culture* (London, 1990); Laleh Bakhtiar, *Sufi Expressions of the Mystic Quest* (London, 1976); Titus Burckhardt, *L'Art de l'Islam, langage et signification* (Paris, 1985). An interesting book published recently explores a new linguistic aspect of Arabic calligraphy. Using computer technology it examines letter-frequency and the influence this has had on ornamental inscriptions: Vlad Atanasiu, *De la fréquence des lettres et de son influence en calligraphy arabe* (Paris, 1999).

3. Dodd and Khairallah, *The Image of the Word*.

4. Wittgenstein, *Tractatus logico-philosophicus*, p.172. See also Brenner, *Wittgenstein's Philosophical Investigations*, pp.32–3.

5. See the analysis of the various types of inscriptions in the Alhambra by Grabar, *The Alhambra*.

6. Ibid., p.76.

7. There is now a need to see whether this type of visual metaphor exists in other Islamic works of art.

8. Wittgenstein, *Tractatus*, pp.247, 273.

9. This overall approach is the one advanced by Dodd and Khairallah in *The Image of the Word*.

10. Grabar, *The Alhambra*, pp.75–7.

11. See Oleg Grabar, *The Shape of the Holy: Early Islamic Jerusalem* (Princeton,

N.J., 1996).

12. Quoted by Garcia Gomez, *Poemas árabes en los muros y fuentes de la Alhambra*, p.35.

13. See Peter Morgan, 'Samanid Pottery, Types and Techniques' in Ernst J. Grube, *The Nasser D. Khalili Collection of Islamic Art: Cobalt and Lustre* (London, 1994), vol. 9, pp.55–113.

14. The collection at the Musée de la Faïence in Geneva has very fine examples of this type of ceramic.

15. See, for example, the devices in Grube, *The Nasser D. Khalili Collection of Islamic Art*, p.94 (no. 88), p.96 (no.92); Stuart Cary Welch et al., *Treasures of Islam* (Geneva, 1985), p.210 (no.197).

16 Mallarmé writing to J. Huret, in *L'Echo de Paris* (Paris, 1891).

17. Lisa Golombek, 'The Draped Universe of Islam', in Priscilla P. Soucek, ed., *Content and Context of Visual Arts in the Islamic World* (Pennsylvania and London, 1988), p.35. See also Lisa Golombek, 'Plaited Kufic on Samanid Epigraphy Pottery', *Ars Orientalis*, 6 (1996), p.107.

18. Derrida, *Edmund Husserl's Origin of Geometry*, p.89, n.92.

19. Jacques Derrida after Edmund Husserl in *Edmund Husserl's Origin of Geometry*, p.97.

20. Ibid., pp.88–9.

21. Burckhardt, *L'Art de l'Islam*, p.23.

22. Atanasiu, *De la fréquence des lettres et de son influence en calligraphie arabe*, p.62.

23. Concerning the general question of the treatment of figuration in Islam, see Gonzalez, 'Réflexions esthétiques sur l'approche de l'image dans l'art islamique', in Clement Beaugé, ed., *La Question de l'image dans le monde arabe* (Paris, 1995), pp.69–78. See also the analysis of the specific images in so-called 'Arab painting' in Dominique Clevenot, *Une ésthétique du voile, Essai sur l'art arabo-islamique* (Paris, 1994), pp.89–122.

24. See Richard Ettinghausen, *La Peinture arabe* (Geneva, 1962).

25. Thierry Raspail, *Edward Ruscha* (Lyon, 1985), p.8.

26. Let us mention that figurative decoration on ceramics and metalwork altogether is concerned with the same treatment of texts and images. A noticeable exception is that of Fatimid ceramics that display very animated figurations thereby entering the category of three-dimensional representation.

27. Among numerous bibliographical references to modern Islamic painting, see: Thomas W. Lentz and Glenn D. Lowry, *Timur and the Princely Vision:*

Persian Art and Culture in the Fifteenth Century (Washington D.C., 1989); Abolala Soudavar, *Art of the Persian Courts* (New York, 1992); Yuri A. Petrosyan, *Pages of Perfection: Islamic Paintings and Calligraphy from the Russian Academy of Sciences, St Petersburg* (Lugano, 1995); Francis Richard, *Splendeurs persanes, manuscrits du XIIe au XVIIe siècle* (Paris, 1997).

28. See the photographs in the exhibition catalogue Welch, et al., *Treasures of Islam*, pp.121, 149, 153, 190 and 191.

Bibliography

Arkoun, Mohammed. *Lectures du Coran*. Paris, 1982.

—— *Essais sur la pensée Islamique*. Paris, 1984.

Atanasiu, Vlad. *De la fréquence des lettres et de son influence en calligraphie arabe*. Paris, 1999.

Audi, Robert, ed. *The Cambridge Dictionary of Philosophy*. Cambridge, Mass., 1997.

Bachelard, Gaston. *La Poétique de l'espace*. Paris, 1978. English tr., Maria Jolas, *The Poetics of Space*. Boston, 1964.

Badawi, 'Abderrahman. *La Transmission de la philosophie grecque au monde arabe*. Paris, 1958.

—— *Histoire de la philosophie en Islam, Les Philosophes purs*. Vol. 2. Paris, 1972.

Baggi, Serpil. 'A New Theme of the Shirazi Frontispiece Miniatures: The Dīvān of Solomon', *Muqarnas*, 12 (1995), pp.101–11.

Bahnassi, Afif. *Dictionnaire trilingue des termes d'art, français-anglais-arabe*. Beirut, 1981.

Bakhtiar, Laleh. *Sufi Expressions of the Mystic Quest*. London, 1976.

Barnes, Jonathan, ed. *The Complete Works of Aristotle*, revised tr. 2 vols. Princeton, N.J., 1991.

Baxandall, Michael. *Patterns of Intention*. Yale, C.T., 1985.

Blacker, Carmen and Michael Loewe, eds. *Ancient Cosmologies*. London, 1975.

Boi, Luciano. *Le Problème mathématique de l'espace, une quête de l'intelligible*. Berlin and Heidelberg, 1995.

Brenner, William H. *Wittgenstein's Philosophical Investigations*. Albany, N.Y., 1999.

Brosh, Na'ama and Rachel Milstein. *Biblical Stories in Islamic Paintings.* Jerusalem, 1991.

al-Bukhārī, Muḥammad b. Ismā'īl. *Les Traditions Islamiques.* Paris, 1984.

Burckhardt, Titus. *L'Art de l'Islam, langage et signification.* Paris, 1985.

Chabbi, Jacqueline. *Le Seigneur des tribus, l'Islam de Mahomet.* Paris, 1997.

Chmelnizkij, Sergei. 'Methods of Constructing Geometric Ornamental Systems in the Cupola of the Alhambra', *Muqarnas*, 6 (1989), pp.43–9.

Clévenot, Dominique. *Une ésthétique du voile, essai sur l'art arabo-islamique.* Paris, 1994.

Cleyet-Michaud, Marius. *Le Nombre d'or.* Paris, 1973.

Cohen, Laurent. *Le Roi Salomon.* Paris, 1997.

Danto, Arthur. *The Transfiguration of the Commonplace.* Cambridge, Mass., 1981. French tr., Claude Hary-Schaeffer, *La Transfiguration du banal.* Paris, 1989.

Davenport, Anne. 'The Catholics, the Cathars, and the Concept of Infinity', *Isis*, 98 (1997), pp.263–95.

de Bruyne, Edgar. *Études d'esthétique médiévale.* 2 vols, 2nd ed., Paris, 1998.

de Libera, Alain. *Averroès, l'intelligence et la pensée, Sur le De Anima.* Paris, 1998.

Derrida, Jacques. *Edmund Husserl's Origin of Geometry: An Introduction*, tr., John P. Leavey. Lincoln and London, 1989.

Dodd, Erika and Sheila Khairallah. *The Image of the Word.* Beirut, 1981.

Eco, Umberto. *The Aesthetics of Thomas Aquinas.* Cambridge, Mass., 1988.

Ettinghausen, Richard. *La Peinture arabe.* Geneva, 1962.

Fernandez Puertas, Antonio. *The Alhambra: From the Ninth Century to Yūsuf I.* London, 1997.

Fried, Michael. *Three American Painters.* Cambridge, Mass., 1965.

Frye, Northrop. *Le Grand code.* Paris, 1984.

García Gómez, Emilio. *Poemas árabes en los muros y fuentes de la Alhambra.* Madrid, 1985.

al-Ghazālī, Abū Ḥāmid. *Le Tabernacle des lumières, Mishkāt al-anwār*, tr. René Deladrière. Paris, 1981.

Golferich, Macario. *La Alhambra.* Barcelona, 1929.

Golombek, Lisa. 'Plaited Kufic on Samanid Epigraphy Pottery', *Ars Orientalis*, 6 (1966), pp.107–33.

—— 'The Draped Universe of Islam', in Priscilla P. Soucek, ed., *Content and Context of Visual Arts in the Islamic World.* Philadelphia and London, 1988. pp. 25–38.

Gonzalez, Valérie. *Emaux d'al-Andalus et du Maghreb.* Aix-en-Provence, 1994.

—— 'The Aesthetics of Islamic Art: Toward a Methodology of Research', *al-Uṣūr al-Wusṭā, The Bulletin of Middle East Medievalists,* 7 (1995), pp.28–9.

—— 'Réflexions esthétiques sur l'approche de l'image dans l'art Islamique', in Clement Beaugé, ed., *La Question de l'image dans le monde arabe.* Paris, 1995. pp.69–78.

—— 'Gülru Necipoğlu, The Topkapi Scroll: Geometry and Ornament in Islamic Architecture', in *Bulletin Critique des Annales Islamologiques,* 16 (1997).

—— *Le Piège de Salomon, la pensée de l'art dans le Coran.* Paris, 2001.

Goodman, Nelson. *Languages of Art, An Approach to a Theory of Symbols,* 2nd ed. Indianapolis, 1976. French trans. and annotation, Jacques Morizot, *Langages de l'art.* Nîmes, 1990.

Grabar, Oleg. *The Alhambra.* Sebastopol, Calif., 1992.

——*The Shape of the Holy: Early Islamic Jerusalem.* Princeton, N.J., 1996.

—— 'A Paradise of Reflections', *Times Literary Supplement* (7 November, 1997), pp.12–13.

Grube, Ernst J. *The Nasser D. Khalili Collection of Islamic Art: Cobalt and Lustre,* vol. 9. London, 1994.

Husserl, Edmund. *Cartesian Meditations: An Introduction to Phenomenology.* The Hague, 1970.

Ibn Ḥazm. *Ṭawq al-ḥamāma.* English tr., A.J. Arberry, *The Ring of the Dove.* London, 1953.

Ibn Rushd (Averroës). *Paraphrases in Libros Rhetoricum Aristotelis,* ed. 'Abderrahman Badawi. Cairo, 1960.

—— *Talkhīṣ kitāb al-ḥāss wa'l-maḥsūs,* in *Arisṭuṭālīs fi'l-nafs,* ed. 'Abderrahman Badawi. Kuwait and Beirut, 1980.

Ibn Sīnā (Avicenna). *Kitāb al-najā,* ed. Majīd Fakhrī, Beirut, 1985.

Jachimowicz, Edith. 'Islamic Cosmology', in Carmen Blacker and Michael Loewe, eds, *Ancient Cosmologies.* London, 1975, pp.143–71.

Jimenez, Marc. *Qu'est-ce que l'esthétique?* Paris, 1997.

Kheirandish, Elaheh. *The Arabic Version of Euclid's Optics* (Kitāb Uqlīs fī Ikhtilāf al-Manāẓir). 2 vols. Cambridge, 1999.

Lassner, Jacob. *Demonizing the Queen of Sheba: Boundaries of Gender and Culture in Postbiblical Judaism and Medieval Islam.* Chicago and London, 1993.

Lentz, Thomas W. and Glenn D. Lowry. *Timur and the Princely Vision: Persian Art and Culture in the Fifteenth Century.* Washington D.C., 1989.

Lindberg, D.C. 'Alhazen's Theory of Vision and its Reception in the West', *Isis,* 58 (1967), pp.321–41.

——— *Theories of Vision from al-Kindī to Kepler.* Chicago, 1976.

Machamer, Peter K. and Robert G. Turnbull, eds. *Studies in Perception: Interrelations in the History of Philosophy and Science.* Columbus, 1978.

Merleau-Ponty, Maurice. *Phénoménologie de la perception.* Paris, 1945.

Morgan, Peter. 'Samanid Pottery, Types and Techniques', in Ernst J. Grube, *The Nasser D. Khalili Collection of Islamic Art: Cobalt and Lustre,* vol. 9. London, 1994. pp.55–113.

Murdoch, John. 'Infinity and Continuity', in Norman Kretzmann, Anthony Kenny, Jan Pinborg, eds, *The Cambridge History of Later Medieval Philosophy.* Cambridge, 1982, pp.564–91.

Necipoğlu, Gülru. *The Topkapi Scroll: Geometry and Ornament in Islamic Architecture.* Santa Monica, Calif., 1995.

Nequam, Alexander. *Speculum speculationum.* Oxford, 1988.

Nykl, Alois R. 'Inscripciones árabes de la Alhambra y del Generalife', *al-Andalus,* 4 (1936), pp.174–203.

Opticae Thesaurus, Alhazen Arabis libri septem nuncprimum editi. Eiusdem liber de Crepusculis et Nubium ascensionibus. Item Vitellonis Thuringopoloni libri X, ed., F. Basilea Risner, 1572; ed., D.C. Lindberg. New York, 1972.

Ozdural, Alpay. 'Omar Khayyam, Mathematicians and *Conversazioni* with Artisans', *Journal of the Society of Architectural Historians,* 54 (1994), pp.54–71.

Panofsky, Erwin. *Meaning in the Visual Arts.* Chicago, 1982.

Perez Sordo, Maria Teresa and Pablo Nestares Pleguezuelo. *Tramas geométricas en la decoracîon ceràmica de la Alhambra.* Granada, 1990.

Petrosyan, Yuri A. *Pages of Perfection: Islamic Paintings and Calligraphy from the Russian Academy of Sciences, St Petersburg.* Lugano, 1995.

Popper, Frank. *L'Art cinétique.* Paris, 1970.

Puerta Vílchez, José Miguel. *Historia del pensamiento estético árabe, al-Andalus y la estética árabe clásica.* Madrid, 1997.

Qur'an. tr., Aḥmad 'Alī. Princeton, N.J., 1994.

Raspail, Thierry. *Edward Ruscha.* Lyon, 1985.

Renard, John. *Seven Doors to Islam: Spirituality and the Religious Life of Muslims.* Berkeley, Calif., 1996.

Richard, Francis. *Splendeurs persanes, manuscrits du XIIe au XVIIe siècle.* Paris, 1997.

Ricoeur, Paul. *La Métaphore vive.* Paris, 1994.

Rodriguez Cabanelas, Dario. *El techo del Salon de Comares en la Alhambra, Decoración, Policromía, Simbolismo y Etimología.* Granada, 1970.

——— 'La antigua polichromía del techo de Comares en la Alhambra', *al-Andalus,*

35 (1970), pp.423–51.

Rosenthal, Mark. *Abstraction in the Twentieth Century: Total Risk, Freedom, Discipline.* New York, 1996.

Rubiera, Maria Jesus. *La Arquitectura en la literatura árabe, Datos para una estética del placer.* Madrid, 1988.

Russell, Bertrand. *The Analysis of Mind.* London, 1921.

—— *Our Knowledge of the External World.* London, 1922.

Sabra, Abdelhamid I. 'Sensation and Inference in Alhazen's Theory of Perceptual Vision', in Peter K. Machamer and Robert G. Turnbull, eds, *Studies in Perception: Interrelations in the History of Philosophy and Science.* Columbus, Ohio, 1978, pp.160–85.

—— *The Optics of Ibn al-Haytham,* I–III. Kuwait and London, 1983–1989.

el-Said, Issam. *Islamic Art and Architecture, The System of Geometric Design,* ed., Tarek al-Bouri and Keith Critchlow. London, 1993.

Saison, Maryvonne. 'Le Tournant esthétique de la phénoménologie', *Revue d'esthétique, Esthétique et phénoménologie,* 36 (1999), pp.125–40.

Schimmel, Annemarie. *Calligraphy and Islamic Culture.* London, 1990.

Schwarzbaum, Haim. *Biblical and Extra-Biblical Legends in Islamic Folk Literature.* Waldorf-Hessen, 1982.

Seligsohn, Max. 'Solomon in Rabbinical Literature and Legend', in *Jewish Encyclopaedia.* New York and London, 1905. Vol. 2, pp.438–44.

Serres, Michel. *Les Origines de la géométrie.* Paris, 1993.

Sidersky, David. *Les Origines des légendes musulmanes dans le Coran et dans la vie des prophètes.* Paris, 1933.

Sluga, Hans and David G. Stern, eds. *The Cambridge Companion to Wittgenstein.* Cambridge, 1996.

Soucek, Priscilla P. 'The Temple of Solomon in Islamic Legend and Art', in Joseph Gutmann, ed., *The Temple of Solomon.* Montana, 1976. pp.73–123.

—— 'Solomon's Throne/Solomon's Bath: Model or Metaphor?', *Ars Orientalis,* 23 (1993), p.118.

Soudavar, Abolala. *Art of the Persian Courts.* New York, 1992.

Sourdel, Dominique and Janine Sourdel. *Dictionnaire historique de l'Islam.* Paris, 1996.

Titley, Norah M. *Persian Miniature Painting.* London, 1983.

Vanel, Hervé. 'Rothko artiste du yo-yo', *L'Oeil,* 502 (1999), pp.39–40.

Various. *L'Art au regard de la phénoménologie.* Toulouse, 1994.

Wansbrough, John E. *Qur'anic Studies: Sources and Methods of Scriptural Interpretation*. Oxford, 1977.

Welch, Stuart Cary, et al. *Treasures of Islam*. Geneva, 1985.

Wittgenstein, Ludwig. *The Blue and Brown Books*. 2nd ed., Oxford, 1960.

—— *Tractatus Logico-philosophicus, suivi de Investigations philosophiques*, French tr., Pierre Klossowski. Paris, 1961; English tr., Charles K. Ogden. New York, 1999.

—— *Philosophical Investigations*, English tr., Gertrude E.M. Anscombe, Oxford, 1972.

Index